# PENCIL DRAWING TECHNIQUES

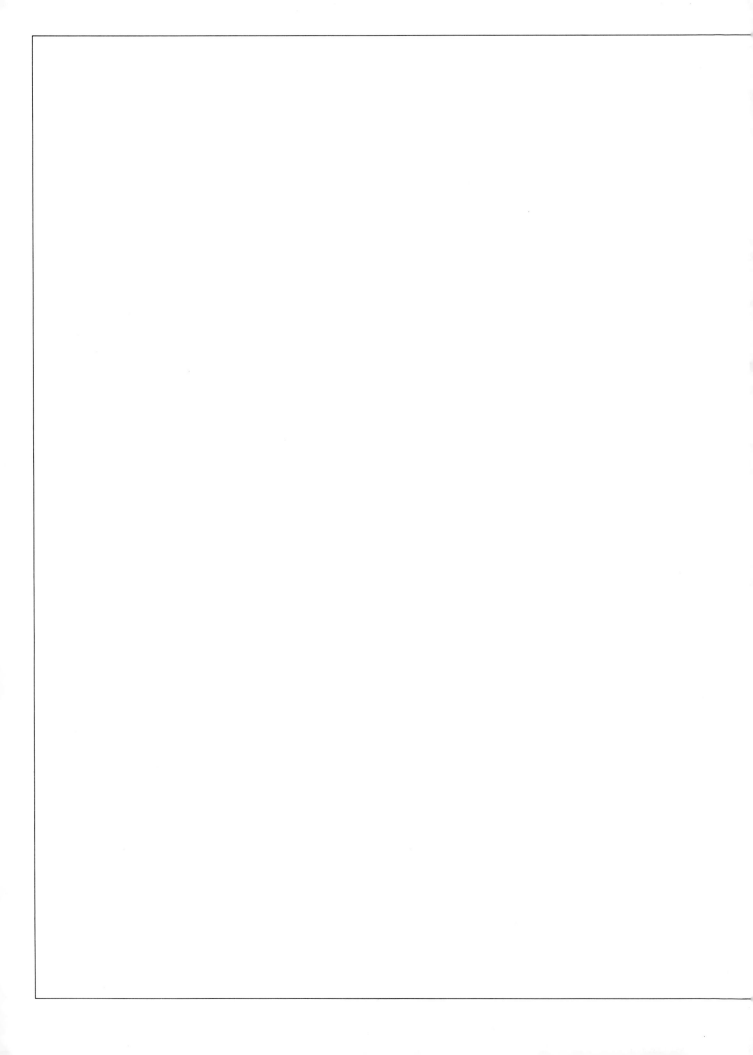

# PENCIL DRAWING TECHNIQUES

## EDITED BY DAVID LEWIS

WATSON-GUPTILL PUBLICATIONS/NEW YORK

Copyright © 1984 by Watson-Guptill Publications

First published 1984 in New York by Watson-Guptill Publications,
a division of Billboard Publications, Inc.,
770 Broadway, New York, N.Y. 10003

**Library of Congress Cataloging in Publication Data**

Main entry under title:
Pencil drawing techniques.
 Includes index.
 1. Pencil drawing—Technique.
NC890.P4 1984    741.2′4    84-2331
ISBN 0-8230-3991-9

Distributed in the United Kingdom by Phaidon Press Ltd., Littlegate
House, St. Ebbe's St., Oxford

Manufactured in U.S.A.
    20  21  22  23  24  25  26  27/08  07  06  05  04  03  02  01

The artists whose work and teaching are included in this book deserve particular recognition and thanks. Because of their generosity and willingness to be involved in this project, *Pencil Drawing Techniques* is the special, first-class instructional volume I'd hoped it would be.

David Lewis

# Contents

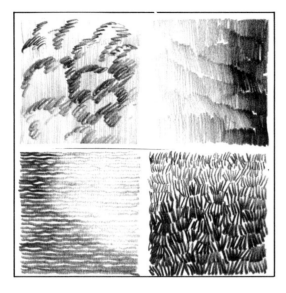

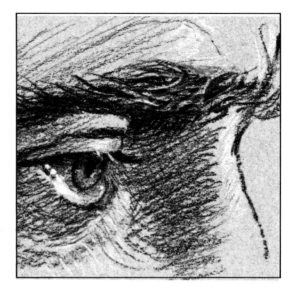

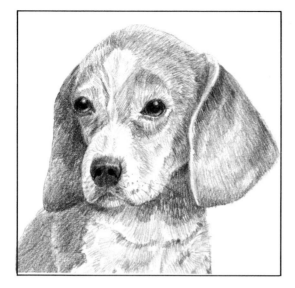

# Introduction

There's nothing like good teaching when you start a new project: it's wonderful when there's someone there who can give you direction, answer your questions, keep you on track, and, after you've mastered tried and true methods, encourage you to experiment with new techniques.

When you're able to confer with *more* than just *one* teacher, you can benefit from the fresh observations and ideas each instructor has to offer. Each one can present you with individual challenges you couldn't get with just one viewpoint. Exposed to a variety of styles and applications, you can get a broader perspective that will stimulate and inspire your own ideas!

If you want to learn how to use the pencil creatively, *Pencil Drawing Techniques* provides this kind of instruction. What is unique about *Pencil Drawing Techniques* among art instruction books, is that it includes the teaching of seven of the best contemporary artists—not just one—so you can grasp the solid instruction and suggestions of several good craftsmen who have become successful using the very techniques included in this book. These seven instructors are all renowned artists in their fields who have previously written successful books for the amateur and intermediate artist. Choice selections from these books have provided the lively text for *Pencil Drawing Techniques*, and together, have helped to create a kind of sampler volume of Watson-Guptill's fine drawing books.

Here's some information on the artists and the books on which *Pencil Drawing Techniques* is based:

**Ferdinand Petrie** teaches two important aspects of drawing with the pencil. After a thorough explanation on handling the pencil—loosening-up exercises, creating values and forms, using fundamental strokes—Petrie explores using the medium to create landscapes—not preliminary sketches—but drawings complete in their own right. These selections were taken from Ferdinand Petrie's very successful book, *Drawing Landscapes in Pencil,* but you should certainly know about his other books for which he provided the paintings to accompany Wendon Blake's text: *Landscape Drawings, Starting to Draw, The Drawing Book,* and *Painting in Alkyd.*

**Rudy De Reyna,** was one of America's foremost realist painters and author of the best-selling classic *How to Draw What You See,* excerpted here. The acclaimed artist explores the fundamentals of drawing, including perspective, basic forms, and how to draw objects using basic forms. He is also the author of several widely-read books on realism, including, *Magic Realist Watercolor Painting, Magic Realist Painting Techniques, Magic Realist Landscape Painting,* and *Creative Painting From Photographs.* He has also provided the paintings for four highly successful books on acrylic painting written by Wendon Blake: *Acrylic Painting, Landscapes in Acrylic, Seascapes in Acrylic, The Acrylic Painting Book.*

**Douglas Graves,** the noted portraitist, is featured in the section on drawing portraits. He's the author of three of Watson-Guptill's well-received books on portraiture: *Drawing Portraits,* excerpted here, *Drawing a Likeness* and *Life Drawing in Charcoal.*

**Norman Adams** draws incredibly charming—and revealing—animal portraits. Majestic lions, playful tigers, horses, dogs, and furry rabbits are all represented here. This section was excerpted from the book he wrote with Joe Singer, *Drawing Animals.*

**John Blockley** and **Richard Bolton** are two famed British artists featured in the Drawing for Watercolors section. Here you'll read their inspiring thoughts on using the pencil to capture the essence of a subject you plan to paint later. John Blockley's ideas were culled from his celebrated book *Country Landscapes in Watercolor.* Richard Bolton's thoughtful observations were selected from his highly successful book *Weathered Textures in Watercolor.*

**Bet Borgeson's** definitive work on using the colored pencil comprises the section on drawing with that medium. The excerpt from *The Colored Pencil* includes solid instruction and suggestions for achieving delightful results, such as burnishing your colored pencil work, or using the medium with a solvent.

By the time you've finished this book, you'll have studied the instructions and ideas of seven of the best contemporary artists. In addition, you'll have sampled several of Watson-Guptill's finest drawing books, and two excellent Watson-Guptill watercolor books. Your "teachers" will have started you on your way, encouraged you, and provided you with the direction you need to use the pencil creatively and with confidence.

# HANDLING THE PENCIL

Like the athlete who is ready for the challenge of competition, you are now ready to begin drawing. However, before the athlete starts the game, he must "loosen up" to relieve tension. The same is true for the artist. You must loosen up before you meet the challenge of that white paper.

In this section you'll learn how to hold the pencil and how to loosen up. Then you'll discover how to create values, forms, and textures with the pencil and how to smudge for tones.

# How To Handle the Pencil

**HOLDING THE PENCIL**
When you start to draw, hold the pencil two different ways. The first is the way you hold a pencil to write a letter. The second is how you normally hold a brush for oil painting—between the thumb and first finger, with the pencil under the palm of the hand. Notice in the illustration (right) how the little finger acts as a guide for your hand. It is easier to control the amount of pressure on the pencil when you let the nail of your little finger glide over the paper. In both methods of holding the pencil, do not grip it too tightly.

**Hold the pencil in the most comfortable manner for you. Ferdinand Petrie uses these two methods because they are the most natural for him.**

**LOOSENING-UP EXERCISES**
Using an HB pencil, loosen up with a series of lines, circles, and ovals. Do not spend a lot of time with each, but do them very quickly (right). Try to achieve complete control of the pencil by using the whole arm instead of just the fingers. You will eventually obtain even circles, lines, and tones.

In making the beginning circle exercise, start with your pencil above the paper and your little finger on the paper. Make a circular motion with your hand. As you get the rhythm of the circle, lower the pencil to the paper. Repeat the same procedure with each circle, doing each very quickly. Fill a page of these circles by pressing heavily on the paper, and finish the circle with light pressure. After you get the rhythm and the circles are clean, reverse this procedure.

Next, do a series of straight lines. By again varying the direction and the pressure, notice the various effects you can obtain.

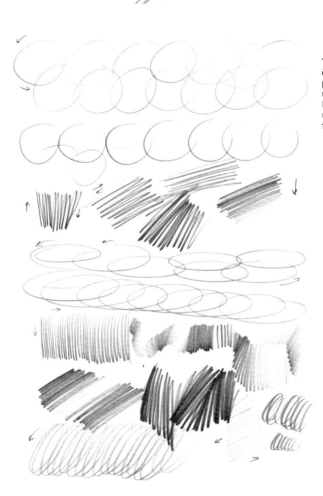

**Try these loosening-up exercises with different grade pencils. Notice the dark values you can obtain with the B pencils. Do these quickly, using your arm, not just the fingers.**

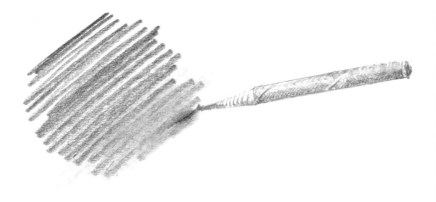

Smudging is done mostly with the softer pencils from HB to 6B. You can also smudge with a cloth or tissue wrapped around your finger.

## SMUDGING FOR TONES
Many artists use a paper stump and smudge or blend their pencil drawings to give a very lean, almost photographic quality. Ferdinand Petrie occasionally uses this method, but only where he wants to create a soft blending of the edges of a vignette. He does not recommend this technique when drawing on location. There is a tendency in smudging to indicate even the slightest value changes. This is difficult to do when you are outside and the light is changing rapidly. Also, smudging obscures the special quality and charm of the pencil strokes. To see an example of a drawing done by using smudging techniques, turn to page 45.

## CHOOSING PENCILS
If you were to look in a catalog from one of the large art suppliers, you would find many types of pencils. There are carbon pencils, drawing pencils, ebony, flat sketching, layout, charcoal, China marking, etc. Each is used for a specific purpose and has its own characteristics. For example, the ebony pencils are very black and are good to use when reproducing your work. The flat sketching pencils contain square leads that become a chisel point when sharpened. Chisel point drawing is excellent for quick sketching and architectural renderings. Layout pencils were used for advertising layouts before markers were invented. They contain flat leads that are about ½″ (1.3 cm) wide, and are used now mostly for quick sketching. Charcoal pencils are familiar to oil painters who use them for their initial drawings, and charcoal is also used for portrait drawings. China marking pencils are wax crayons used for working on slick surfaces, like photographs, which will not take a carbon pencil.

The type of pencil Ferdinand Petrie uses is the graphite or more commonly called "lead" pencil. The graphite pencil comes in various degrees of hardness, designated by letters: "H" for the harder pencils and "B" for the softer ones. They also have numbers that indicate the degree of hardness or softness. For example, 6H is the hardest and 2H is the softest of the hard leads that Mr. Petrie uses. Later on in this section, you will see how the hardness of the lead enables you to create the values you will use in your drawings.

Pencils made by different manufacturers may differ in their degree of hardness or softness. Therefore, it's a good idea to obtain sets of pencils made by the same company. This artist uses hexagon-shaped pencils called "Castell 9000," which are made by the A.W. Faber Company. He uses the

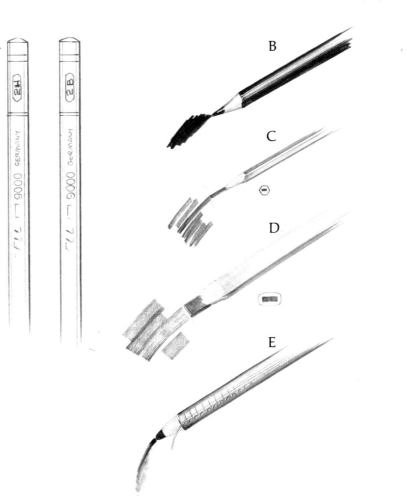

following pencils: 6H, 4H, 2H, HB, 2B, 4B, and 6B. HB is the transition between the hard and soft leads. He has also used the Koh-I-Noor drawing pencil, the Venus pencil, and the Eagle "Turquoise"—all are of excellent quality.

All manufacturers identify the grade pencil by numbers located in the same place (A). Be careful you don't sharpen the wrong end of the pencil and lose the grade number. The leads in the Ebony pencil (B) are round, soft, and very black. The flat sketching or chisel point pencil (C) has the same outside shape as other pencils, but the leads

are rectangular. They can only be sharpened with a razor blade. The flat layout (D) is also called a carpenter's pencil. The leads are usually ³⁄₁₆″ (.48 cm) or ⁵⁄₁₆″ (.80 cm) wide and again must be sharpened with a razor blade. Large areas can be covered quickly, so it is often used for fast sketching. There are many makes and varieties of charcoal pencils (E). Some are similar to the regular lead pencil and can be sharpened with a sharpener. Others like this are paperwrapped and have a string pull to sharpen the pencil.

# Creating Values

The placement of values is of prime importance in the composition of a picture. It is possible to create all the values in a drawing by using just one pencil. To do this, you must use a pencil that will make a dark value. Try using a 2B. By varying the pressure on the paper with a 2B pencil, you can render all values between white and black.

Another way of creating values is by using different grade pencils for different values. You can make all the values between white and black with seven pencils as follows:

| 0 1 | | 2 3 | | 4 | 5 | 6 | 7 8 | 9 | 10 |
|-----|--|-----|--|----|----|----|-----|----|-----|
| 6B | | 4B | | 2B | HB | 2H | 4H | 6H | |

Before you start any drawing, make a chart of all ten values using the pencils suggested here. Make each square 1-inch (2.5 cm) and create the tones with vertical lines, horizontal lines, and cross-hatching. Do each value as carefully and accurately as you can (see above).

There are two other exercises you should do in order to understand values and how to achieve them: 1. Using the seven pencils of grades 6B, 4B, 2B, HB, 2H, 4H, and 6H, make a chart of a graded tone from value 0 (black) to 10 (white). Be sure as you change pencils that there is a gradual blending of the tones. Notice how you can create a very smooth blending from one value to the next by simply changing the pencils. 2. The second exercise is the same graded value chart you did (above) with seven pencils, but now you will use only one pencil that will make a dark enough tone to create a solid black. With a 4B pencil you are able to create all the values from 0 to 9 by changing the pressure. When you grade the values with one pencil, the texture of the paper becomes an important element, since with less pressure the roughness of the paper becomes more apparent (opposite page, bottom)

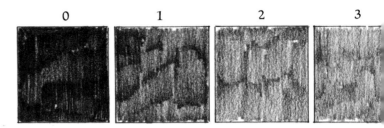

**To create all the values between white and black, use the following pencils: 6B pencil for 0 and 1; 4B for values 2 and 3; 2B for the 4th value; HB for the 5th value; 2H for the 6th value; 4H for values 7 and 8; and 6H for the 9th value. The 10th value is the white paper.**

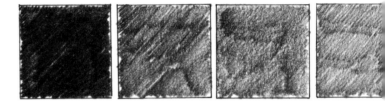

**This chart was created by using the same pencils as above for the values; however, the strokes were drawn on a slant. Use different directions for the strokes, but keep the values the same.**

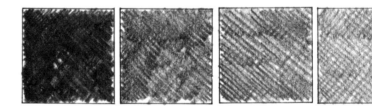

**Only a 2B pencil created the values for this chart. The values were made by cross-hatching and varying the pressure on the paper.**

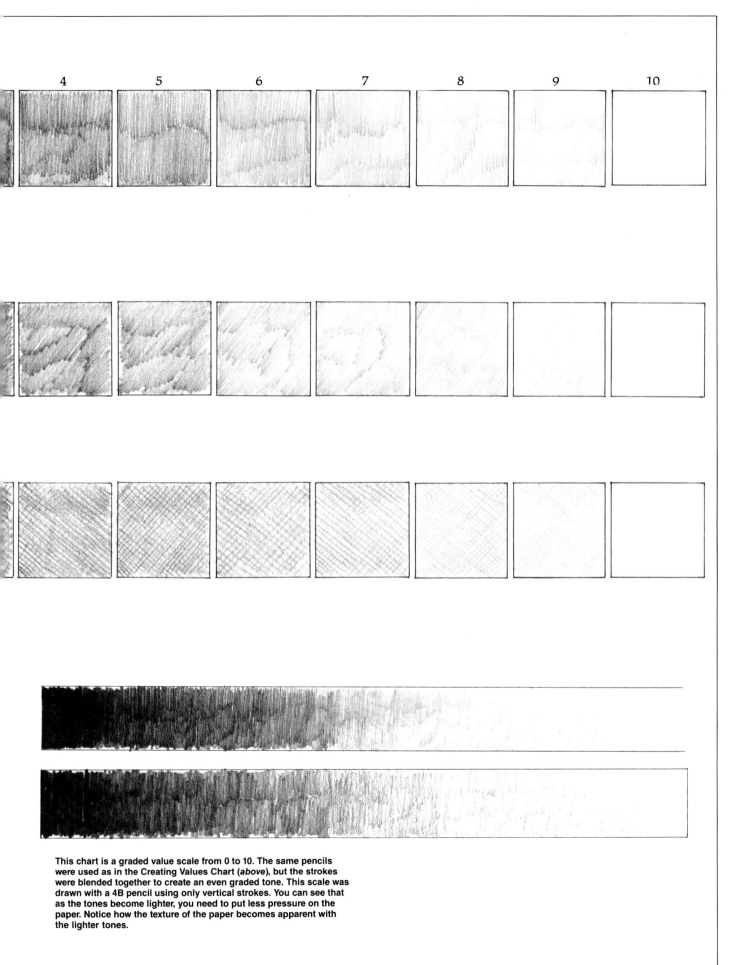

This chart is a graded value scale from 0 to 10. The same pencils were used as in the Creating Values Chart (*above*), but the strokes were blended together to create an even graded tone. This scale was drawn with a 4B pencil using only vertical strokes. You can see that as the tones become lighter, you need to put less pressure on the paper. Notice how the texture of the paper becomes apparent with the lighter tones.

# Creating Forms

One of the most difficult problems of drawing is creating a three-dimensional form on a flat piece of paper. The best demonstration of producing three-dimensions is with a drawing of a cube that has height, width, and depth. If there is a flat overall light on a cube, it is difficult to see the light side, the middle tone side, and the shadow side. When a single light is directed on the cube you will be able to see the height, width, and depth. Each surface of the cube will have a value, and the difference between these values will reflect the amount of light. For example, if the lightest side of the cube is a 9th value and the shadow side is a 1st value, there is a stronger light effect than if the difference were a 7th value for the light and a 5th value for the shadow.

You can create the values you'll use to produce the form with the same methods that were used to make the value charts. Use either one pencil and change the pressure to make the values, or use all seven grade pencils

(see below). With a 2H pencil (A), indicate the light value, the middle value, and the dark value. It is difficult to achieve a strong light effect since the darkest tone you can obtain with a 2H pencil is the 6th value. When you use an HB pencil (B) you can achieve a much stronger light on the cube, since the HB pencil can make a 4th or 5th value. However, by reducing the pressure on the pencil you can create more texture in the middle tone side. A stronger light effect is obtained with a 2B pencil (C) because the shadow side now becomes a 3rd value. Since the pencils are softer, the texture in the paper becomes more noticeable. By using a 6H pencil for the lightest tone, a 2H for the middle tone, and an HB for the shadow (D), you'll have more control in creating the values. The value relationship between the middle tone and the shadow is only one value difference, which gives a very weak light effect. You can obtain a stronger light by using an HB pencil for the middle tone and a 2B for the darks (E).

There is still only a one value difference between these two sides, which does not enhance the form. As in (F) leave the lightest side white. By doing so, you'll make that side as light as possible. In effect, this is the same as using a darker value in the shadows. By keeping the values on each side close together (G), you can achieve the effect of a very dim light. In a landscape, for example, this could give you a very hazy or foggy atmosphere. The value relationship in this cube is 9, 8, 6. You can achieve the strongest contrast in values (H) by keeping the light side white, the middle tone a 6th value with a 2H pencil, and the dark side a 3rd value by using a 4B pencil. You may want to try keeping this value relationship in most of your drawings. In order to create the strongest effect of light possible (I), leave the light side white and the middle tone a 4th value with a 2B pencil and the darks a 3rd value with a 4B pencil. This has the effect of a strong spotlight on a subject.

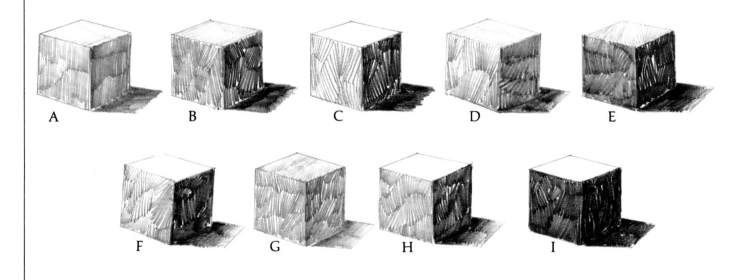

A          B          C          D          E

F          G          H          I

# Fundamental Strokes

There are a few basic strokes that will be helpful when drawing on location if you apply them! You will discover many more strokes on your own as you practice and sketch.

Three pencils, 2H, HB, and 2B, were used here, but do try each exercise with different grade pencils. Keep in mind that strokes of all kinds and combinations should be drawn without trying to create a picture, although some of the exercises may take on the appearance of actual objects (see below).

Here are some of the many strokes and patterns that are created by using the 2H, HB, and 2B pencils: Short vertical strokes (A) with a 2H pencil varying the direction, even pressure. Short strokes (B) at an angle, even pressure, 2H pencil. Short horizontal strokes (C), even pressure, overlapping, 2H pencil. Long vertical strokes (D), irregular lines, even pressure, 2H pencil. Short, curved lines (E) in different directions, 2H pencil. Short, curved strokes (F) in one direction, leaving white spaces, with HB pencil. Short, curved strokes (G) with HB pencil. Vertical background with 2H pencil, using vertical strokes. Short, vertical strokes (H) with 2B pencil, varying the pressure and direction. Short, vertical strokes (I), even pressure, varying the direction with HB pencil. Short, angle strokes (J), varying pressure and direction, with 2B pencil. Combination of 2H, HB, and 2B pencils to vary short angular strokes (K) in various directions. Small, curved lines (L) with 2B pencil, varying the pressure from left to right. Short, vertical strokes (M) with 2B pencil, varying the pressure, and direction. Vertical strokes (N), varying the pressure, leaving white areas. Combination of 2H, HB and 2B pencils with short strokes (O) going in various directions.

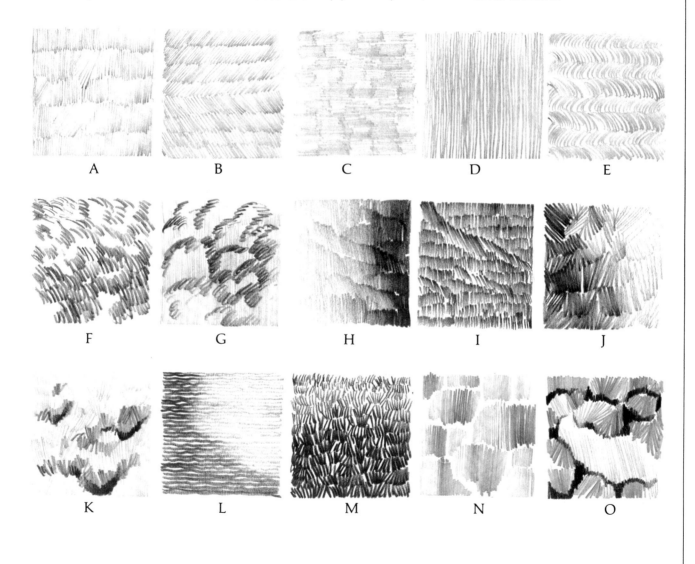

A    B    C    D    E

F    G    H    I    J

K    L    M    N    O

# THE FUNDAMENTALS OF DRAWING

It is very important to learn to draw things *as you see them*—realistically. That is, you must reproduce the dimensions and proportions of a given subject. To render a faithful, realistic drawing, you must be able to observe the basic structure of an object, regardless of how complex and obscured by detail it may be. You must train not only your hands but your eyes as well.

In this section you'll learn how to *see* the four forms that comprise the basic structure of all existing objects. Once you've mastered these forms, you'll be able to draw anything.

# Eye Level: The Foundation of Perspective

Many students fail in their attempts at drawing because they're unaware of eye level. Actually, it's such a simple concept, so seemingly obvious, that perhaps it's this very quality that causes it to be overlooked.

Eye level refers to the *height at which your eyes observe an object*. You may want to write this sentence and place it where you can see it often, so that it becomes part of you. It's that important to your development as an artist.

## CHANGING SHAPES AND EYE LEVEL

To actually demonstrate what is meant by eye level, lie prone on the floor. Notice that you see the bottom, not the top, of most objects. Now sit up and notice the difference; move to a chair and again observe that as you raise your eye level, the top planes of objects come into view. If you were to climb a ladder to the ceiling, everything below you would show its top plane. Sounds simple enough, doesn't it? Well, it is!

## VANISHING POINTS

The cubic form on the opposite page (top) is seen at eye level, and shows only two of its six sides. Its horizontal lines converge down to and up to their respective *vanishing points*. A vanishing point is an imaginary point on the eye level, or horizon, where the parallel edges of a cubic form appear to converge and meet.

Converging lines, eye level, and vanishing points all add up to perspective. It's a word of Latin origin meaning "to look through." In other words, you view an object as though it were transparent and you could see all its sides—front and back.

Actually all you have to do to draw an object in perspective is to observe closely. What's the angle and length of one edge compared to another? What's the length and width of a plane in relation to its neighbor? Asking yourself these kinds of questions as you view an object will help sharpen your powers of observation.

The middle cubic form on the opposite page has all its lines rising to the vanishing points because this cube is below eye level. All the lines of the bottom cube on the opposite page go down to their vanishing points because the cubic form is above eye level. In short, if the cubic form is at eye level, the lines (that form the sides of the cube) come down from the top edges and go up from the bottom edges to their vanishing points on the horizon. If the cubic form is below eye level, all converging lines go up to vanishing points on the horizon. If the form is above eye level, all the converging lines come down to vanishing points on the horizon.

## CUBE IN PERSPECTIVE

Also, the cube clearly demonstrates the illusion of the three dimensions—height, width, and depth—that you must convey on the flat surface of the paper. If you can portray these dimensions, you'll be able to draw realistically, no matter what the subject.

From this moment on, remember the three dimensions that are inherent in everything. Naturally, each dimension can vary. The height of a cubic object can be greater than its depth, or the width can be the largest dimension of the three. As long as you're aware of their relationship, you'll be amazed at the progress you'll make.

Now take a box from your pantry—any box, regardless of its shape—and hold it at eye level. Turn it so you can see only two of its sides, as the top cube on this page. If the design on the package distracts you, tear off the paper covering and work with the bare box.

## JUDGING SIZE RELATIONSHIPS

Drawing realistically means drawing accurately. Whatever proportions your box may have, check the relationship between one side and the other. Notice that in the box at left, its length is about twice its width. The three boxes are seen at three different eye levels. Draw your box in the three different positions shown at left. Use any type of pencil to do the exercises in this section—a regular office pencil will do. It won't matter at all either if your box isn't the same shape as the box pictured here. The main thing is for you to be aware of the object's planes as you raise it or lower it above or below your level of vision.

When you're satisfied that you can draw a cubic shape at eye level, continue with above and below eye level views as on the following page. In the boxes you draw be sure that the lines converging to vanishing points 1 and 2 are at the proper slant, even though the lines can't extend all the way to their respective vanishing points on the eye level—simply because the paper isn't big enough.

## OBJECTS BELOW EYE LEVEL

Most of the objects you'll draw (at least at the beginning) will be indoors and below eye level, because interiors—furniture, rooms, etc.—are scaled to a size that humans can manipulate. Therefore, the reason for drawing objects below eye level is quite obvious. Look around you and notice that even as you sit you can see the tops of tables, chairs, sofas, etc. When you can see the top of an object, it means that it's below the eye level or horizon. Since most of the work you'll do will be from a sitting or standing position, you need to observe the appearance of things from that viewpoint.

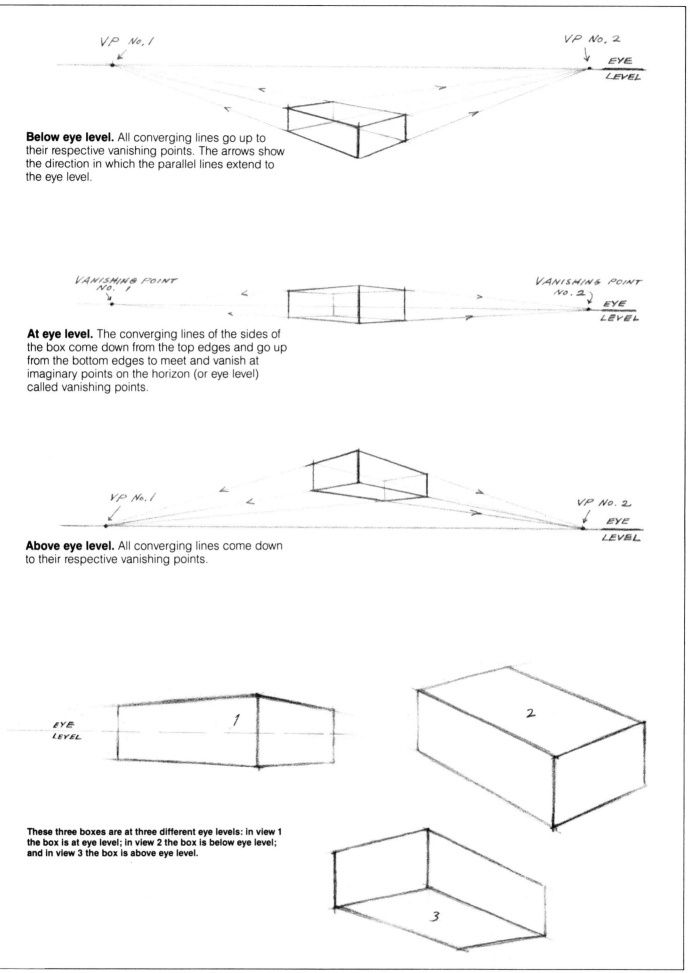

**Below eye level.** All converging lines go up to their respective vanishing points. The arrows show the direction in which the parallel lines extend to the eye level.

**At eye level.** The converging lines of the sides of the box come down from the top edges and go up from the bottom edges to meet and vanish at imaginary points on the horizon (or eye level) called vanishing points.

**Above eye level.** All converging lines come down to their respective vanishing points.

**These three boxes are at three different eye levels: in view 1 the box is at eye level; in view 2 the box is below eye level; and in view 3 the box is above eye level.**

As an object gets farther away from eye level, its verticals get shorter and its vanishing points get farther away from the object.

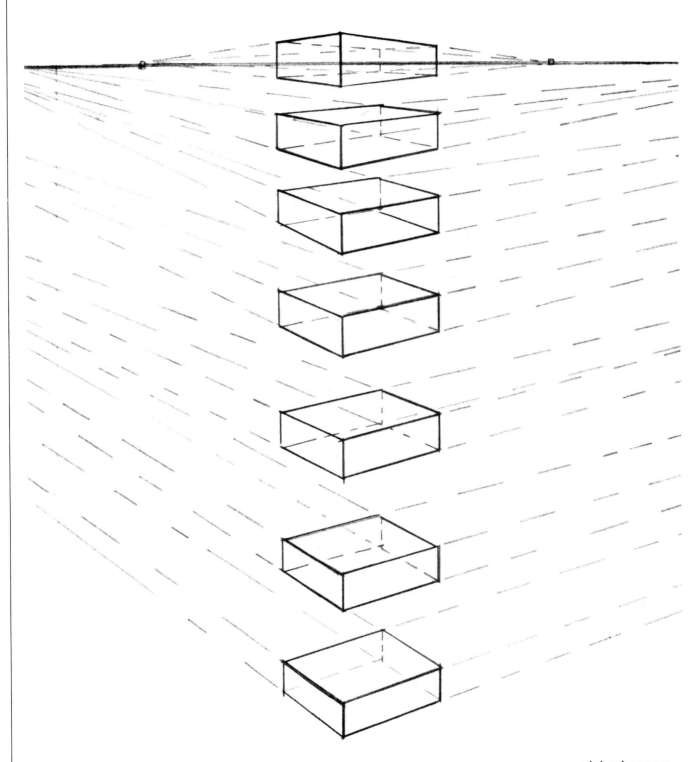

Yes, this caption is supposed to be upside down, so that you can see that the same principle applies when you're looking up at an object. In this and following projects, the vanishing points will usually be beyond the borders of your paper.

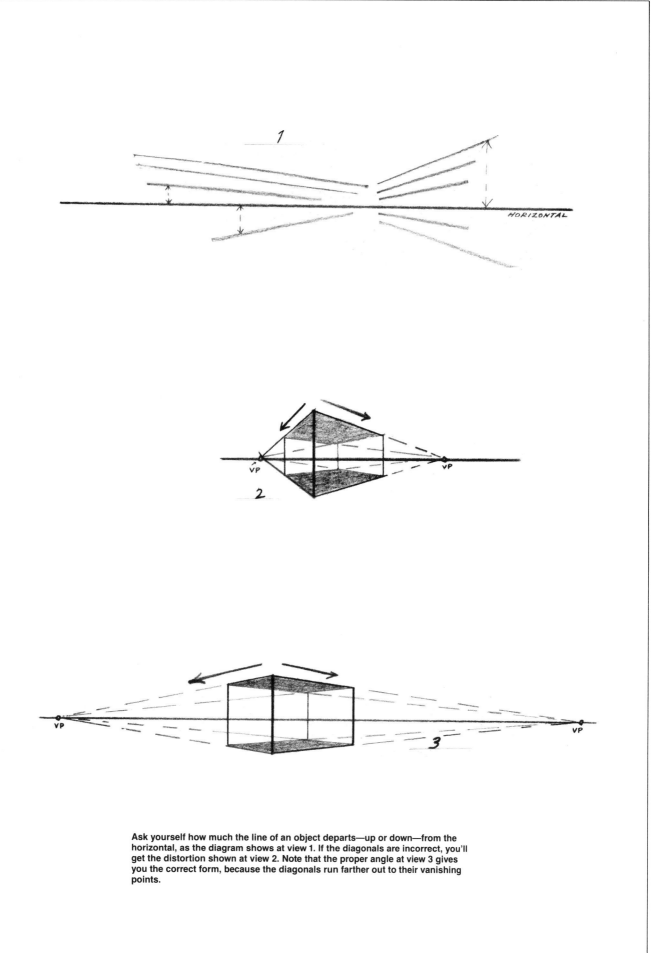

Ask yourself how much the line of an object departs—up or down—from the horizontal, as the diagram shows at view 1. If the diagonals are incorrect, you'll get the distortion shown at view 2. Note that the proper angle at view 3 gives you the correct form, because the diagonals run farther out to their vanishing points.

# Practice Exercises

Collect four boxes and draw them at different distances below eye level. You might place them on top of one another and draw the topmost first; remove it and draw the second, and so on until you've drawn the fourth. Notice that as you come down to the lowest box, you see more of its top plane than you did on the first box. Compare the top planes of all four of them when you've finished.

This type of practice exercise is indispensible. It doesn't result in a drawing worthy of being hung on a wall, any more than the pianist's exercises would be performed in a concert hall. Yet, as you know, the pianist submits to daily practice not only to acquire technique, but to sharpen and control it, even after he or she has mastered the instrument. Flip through the pages of this book, if you haven't done so already, and you'll see that you're going to draw everything, not just boxes. But you must first find your feet before you can run.

A cubic form presents no problem at all if you place it squarely in front of you with only one side visible, as seen at view 1. The horizontals remain horizontal and there's no angle to check. But notice that you lose the cube's sense of solidity and it becomes a flat rectangle. The moment two sides are visible, as in view 2, the cube begins to convey a sense of bulk. There's only one vanishing point here; this is called one point perspective. When three sides are shown, as in view 3, the horizontals have become diagonals, but there's no question about the cube's volume and the space it occupies.

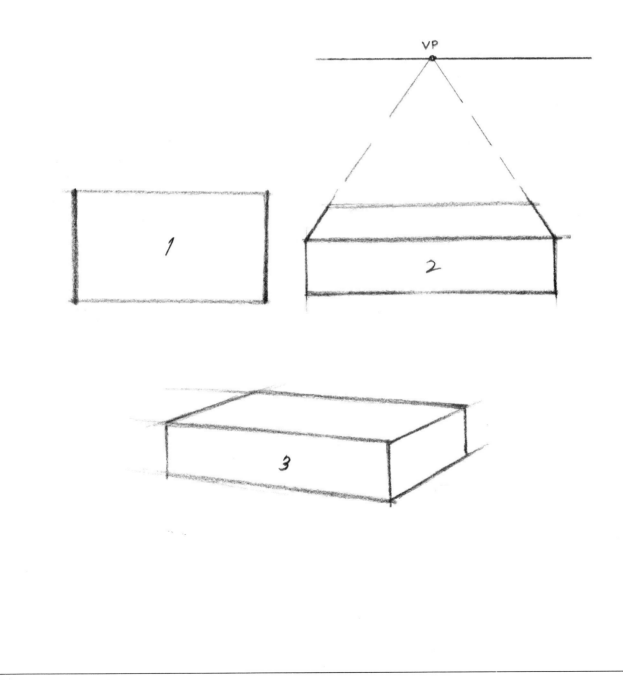

# Drawing Cubic Objects

You can use the same "office" pencil that you've been using, but now get several drawing pads. They come in varying sizes: 9″ × 12″ (23 × 30 cm.), 11″ × 14″ (28 × 35.5 cm.), 12″ × 18″ (30 × 46 cm.), 14″ × 17″ (35.5 × 43 cm.), 19″ × 24″ (48 × 61 cm.). Don't let a salesperson sell you any fancy or expensive paper; it's not necessary at this stage of your development. Besides, you're going to use reams of it just doing the exercises. So get the cheapest—it will be perfectly adequate in these beginning projects.

### CUBIC FORMS IN EVERYDAY THINGS

Now you'll see why bare boxes were dwelt on for so long. You should have been able to see what happens to a cubic form as you turn it, lower it, and raise it. The figures on this and the following page represent only some of the thousands of objects that have the cube as their underlying structure. As a rule, they won't be perfect equilateral cubes. But whether they're long, narrow, and thin or short, wide, and thick, they'll still conform to the cube by having a top, a bottom, and four sides.

### SEARCHING WITH LINES

With this in mind, draw your television set, a box of tissues, one of your tables, and your kitchen range, etc. Sit with your pad on your knees and notice the length compared to the width of the top plane of these objects. Observe the relation of the sides to each other and also to the width and height of the entire object.

If the television set or the range are too difficult for you at this stage, then draw a suitcase or a box of matches. When you've gained more confidence, you can return to the more complex subjects.

Tackle everything! If your hand is still a bit reluctant to do your bidding, let it lag. It will catch up with your demands—it always does. The training of your eye to observe, weigh, and to compare correct relationships is more important. For the moment, let your drawing be labored or even crude, as long as it's correct. Be assured that facility will come in time.

### HANDLING DETAIL

When you're sure that the overall proportions of your objects are correct, proceed to the details it may have. For example, with a television, judge the distance that a knob might be from its edge, as well as the knob's size in relation to the width of the plane that it occupies. Is the knob centered on that plane? If not, how much off-center is it?

If your object is a table and its detail consists only of legs to be added to its top, how thick are these legs in relation to their height or the width of the side panel? If your object is a bookcase and its detail consists of books within it, what's the height and width of the book in the center of the shelf? How short and thick is the next one?

This is important: the large planes and dimensions must be established correctly. You can then subdivide the large shapes into smaller ones, and these in turn should be divided again until you get to the minutest detail.

Using your bookcase as an example, its overall proportions must be established first; then the placement of the shelf or shelves should be determined. Next, the books can be delineated in their proper width and height, followed by the detail on the spine of each book.

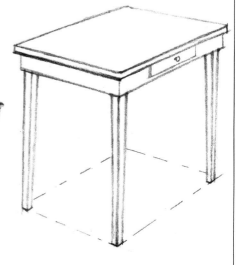

**Note that the broken "guidelines" indicate that the table is a cubic form.**

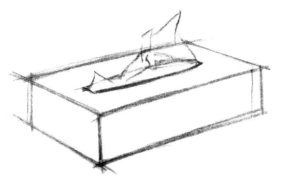

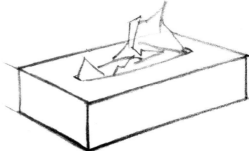

**This tissue box is the simplest form and a good one to begin with.**

All five objects here are below eye level. Note that each object reveals its top plane and two of its sides.

# Using Initial Sketches to Refine Drawings

As you search for the correct width, height, or depth of a plane, you'll draw many inaccurate lines. Don't erase them. Keep searching with other lines until you feel satisfied that you've got the right ones. Accent your correct lines by bearing down on them with your pencil. Place a fresh sheet of paper over your object and pick out only the correct lines, as Rudy De Reyna did with the drawings in this section. You can see that the artist drew all the objects in two stages. In the drawing on the left of each pair of drawings, notice how roughly he indicated the overall shape of the object as he searched for its proper proportions. After finding the right proportions, he darkened the correct lines. Again, never erase. Once you begin to erase, you lose your means of comparing correct to incorrect shapes and dimensions.

Having established the correct proportions the artist placed a fresh sheet of paper (tracing paper is preferred) over the first drawing and "cleaned it up." That is, he transferred only the correct lines to the new sheet of paper. Although you don't have to use tracing paper, you obviously must use paper that's transparent enough for you to see the drawing beneath it.

If some inaccuracies still remain on your second sheet, correct them with new lines. Place another new sheet of paper over them and transfer the corrected drawing.

Use this method of refining your drawings. Begin by drawing every cubic object in the room about you. When you feel that their basic cubic proportions are correct, then, and only then, start adding the details the objects may have.

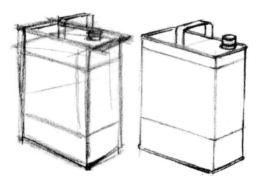
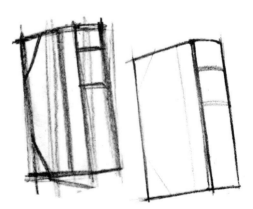

**In each of these three pairs of drawings, the artist began searching for correct dimensions with the sketch on the left. He never erased. If an angle or a line was incorrect, he simply drew another. After darkening the correct lines, he transferred them to a fresh sheet of paper and worked on the corrected drawing that you see on the right side of each pair.**

# Drawing Cylindrical Objects

After doing so many drawings with straight lines, you can probably do them now with ease and confidence. They'll become still easier as you continue with future projects. But if you're to draw objects based on the cylinder, the cone, or the sphere, you must also practice drawing the curved lines that form them.

### DRAWING CURVED LINES

Hold your pencil (still the ordinary "office" kind) in the position you prefer: the usual writing one, or under your palm. Swing your arm from your elbow, and even from the shoulder, if you work big. It may feel awkward at first, but persevere until you feel comfortable. If you hamper your rendering now by working from the wrist—because it "feels more natural"—the beautiful sweep of a fluid line will never be yours.

The only consideration in this second section of the book is to convey the principles of good drawing. Later you'll explore the line and its expressive power. Here, the purpose of your lines is to establish the optical correctness or "reality" of everything you draw.

### OBSERVING CYLINDRICAL FORMS

No matter what the cylindrical object, you must first see the cylinder itself, underlying whatever detail the object may have. In the beginning stages of

your drawings it's a good idea to draw the geometric cylinder first, and then make the required modifications, as the artist did in the demonstrations with the pots (page 29). Later you can dispense with the drawing of the geometric cylinder and begin immediately with the cylindrical object itself.

### RENDERING CYLINDRICAL OBJECTS

Rudy De Reyna's approach to drawing a cylinder is to rough in the entire ellipse (the circle that forms a cylinder's top and bottom) in a counter-clockwise direction. Then he refines the ellipse's visible side by accentuating the correct curvature with heavier strokes.

You may find it easier to rotate your pencil in a clockwise manner. Practice both and stay with your preference; the better result is what counts, not the way you achieve it. Be sure that you check the angle of departure—any indents and bulges—of the object's sides from the vertical of the geometric cylinder.

### ELLIPSES AND PERSPECTIVE

When drawing the cylinder remember that at eye level its ellipse appears to be a straight line. As the ellipse rises above eye level, or the horizon, its edge nearest you curves up in an arc. As the ellipse descends below eye level, the arc is reversed and the edge nearest

you curves down.

Get a glass from your cabinet and draw it as many times as necessary to get the ellipses correct (see pages 27 and 28 for reference). Before you draw the glass, raise it to eye level, so that its top makes a perfectly straight line; notice that the bottom of the glass, being below eye level, forms an ellipse. Now lower your arm gradually and notice that the top of the glass becomes an ellipse that gets wider and wider as you lower the glass more and more. Finally, when the top of the glass is directly below you, the ellipse becomes the full circle that it actually is.

It doesn't matter if the glass you draw doesn't resemble the one used here. The purpose of this exercise is simply to train your eye and hand to observe and render whatever modifications and departures there may be from the rigid cylinder that underlies the shape of the object you're drawing. The correct placement of a handle on a cup, the height of a stem on a glass and the different depths of the upper and lower ellipses of a glass are factors that must be considered when observing and drawing these cylindrical objects. Remember that as an ellipse nears the eye level, or horizon, it gets shallower, and that as the ellipse gets farther away, it gets deeper.

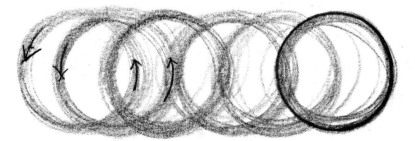

**To insure a fluid and rhythmic line, be sure to swing your curves from your elbow, not from your wrist.**

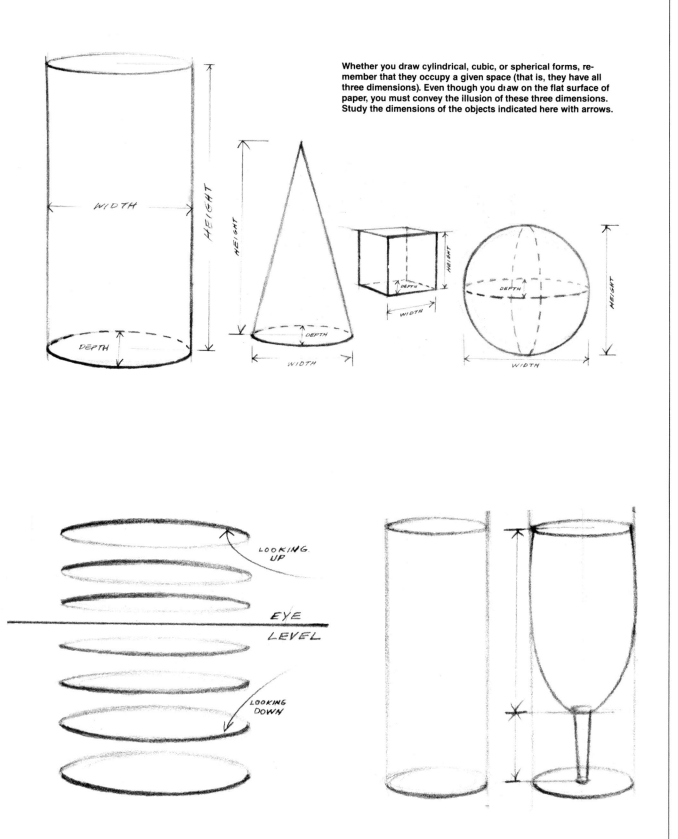

Whether you draw cylindrical, cubic, or spherical forms, remember that they occupy a given space (that is, they have all three dimensions). Even though you draw on the flat surface of paper, you must convey the illusion of these three dimensions. Study the dimensions of the objects indicated here with arrows.

WIDTH

HEIGHT

DEPTH

HEIGHT

DEPTH

WIDTH

HEIGHT

DEPTH

WIDTH

DEPTH

HEIGHT

WIDTH

LOOKING UP

EYE LEVEL

LOOKING DOWN

Always be aware of eye level; the true appearance of objects depends upon it. Notice that the top ellipses of the glasses are shallower than their corresponding bottom ones, because the top ellipses are closer to the eye level and the bottom ones are farther from it.

Take any opened bottle you may have. Hold it straight down at arm's length, and note that the lip of the bottle is a perfect circle, as in view 1. But the ellipse gets more and more shallow as you raise the bottle to eye level; see views 2, 3, and 4. Notice that while the back and front of the bottle's lip get narrower as you lift the bottle to eye level, the left and right ends of the lip remain the same width.

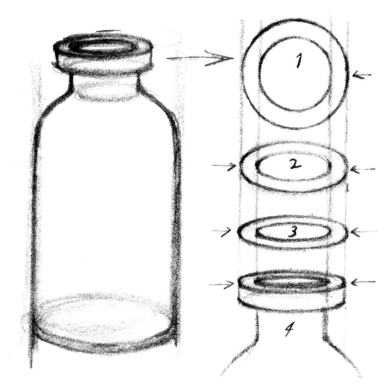

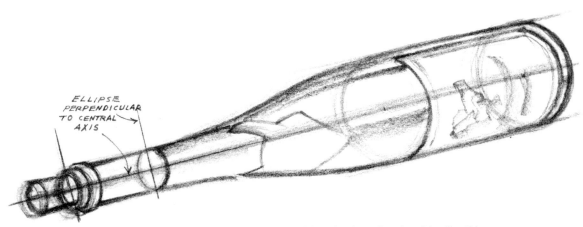

ELLIPSE
PERPENDICULAR
TO CENTRAL
AXIS

When a cylindrical object is placed on its side, like this wine bottle, the ellipses are perpendicular to the central axis of the cylindrical form.

# Drawing the Cylinder First

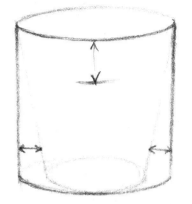

**Flower Pot, 1.** The artist first drew a true cylinder, then determined the sides of the pot and the width of its rim.

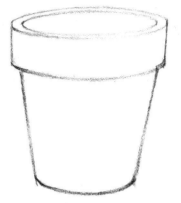

**2.** He darkened the correct lines, then placed a fresh sheet of paper over the drawing and transferred the darkened lines, thereby "cleaning up" his drawing.

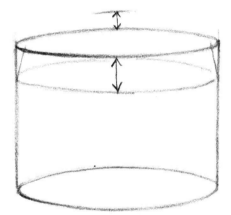

**Cooking Pot, 1.** Again, the artist drew the entire geometric cylinder first. He observed the depth and the width of the pot in relation to its height, and indicated the dimensions of the lid.

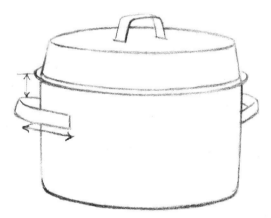

**2.** Here's the refined drawing of the cooking pot. The artist has not yet determined the slant of the pot handles, or the distance from the bottom of the lid to the top of the handles.

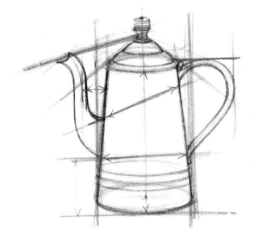

**Coffee Pot, 1.** In actual practice, these accentuated guidelines would be very light—if drawn at all—and just visible enough to establish relationships and checkpoints.

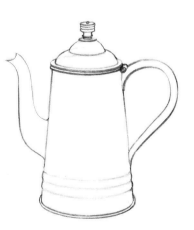

**2.** Following the procedure used in the preceding demonstrations, the artist placed a fresh sheet of paper over the first rough drawing and drew only the pot itself.

# Drawing Spherical Objects

Besides the obvious, perfect spheres that form the structure of a ball—whether a golf, tennis, or basketball—there are those objects which have shapes based on the sphere in one form or another. An egg, a nut, an apple, and an orange all have a modified sphere as their basic underlying form. Objects such as a bowl, a cup, and a tea kettle can be based on part of a sphere.

### DEPARTURES FROM THE GEOMETRIC SPHERE
The departures from the geometric sphere may be quite radical at times, but all the objects on these two pages

are based upon it. For example, in the football the sphere is tapered at both ends; in the coffeemaker there's one complete sphere and two-thirds of another.

When drawing any object that's structurally spherical, draw the complete sphere first; then add the required departures that your particular object demands. You should ask yourself the same questions concerning proportion that you asked when drawing other forms. How much does your object depart—flatten, bulge, or bend—from the geometric sphere you first drew as its basis?

Gather all the spherical objects you

can find and draw them in any size you wish. But be advised to draw rather large, so you can swing your pencil freely.

### DEPTH AND THE SPHERE
As you draw, remember that a sphere occupies a given space; it is not a flat disk. Hold an apple or orange in your hand and feel its bulk. Try to convey this volume and weight in your drawing. In the demonstrations that follow, the artist indicated this three-dimensional feeling by using the ellipses on the apple and orange, and on the geometric spheres upon which they're based.

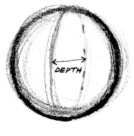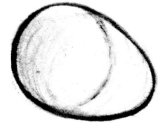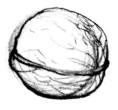

**A sphere provides the basic form for both this egg and this nut. Remember that a sphere has three dimensions. The ellipses on the egg shape help to emphasize its depth.**

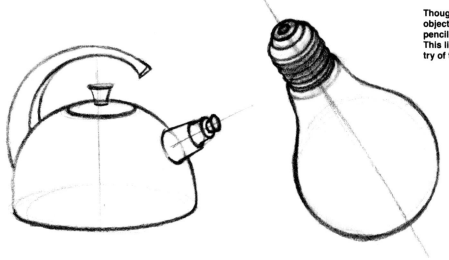

**Though modified in some way, each of these objects is based on the sphere. Notice the light pencil line through the center of each object. This line helped the artist establish the symmetry of the left and right sides of the objects.**

**Tea Cup**

**1.** Some objects have only a part of a sphere in their structure. Even so, begin by drawing the complete sphere, as indicated by the broken line. Notice how the artist's ellipse here establishes the depth of the sphere, giving it volume.

DEPTH

**2.** Now proceed to add the modifications to the sphere that can turn it into a cup. Here, the artist omitted the broken line and worked only with the bottom half of the sphere.

DEPTH

**Apples and Oranges**

**1.** With these fruits, as with any piece of fruit based on the sphere, first draw the complete, geometric sphere. Also draw in ellipses to help establish the third dimension of the sphere—depth.

DEPTH

DEPTH

**2.** Once the basic form is established then you can add the departures that make your particular fruit unique: its bulges, texture, and stem.

# Drawing Conical Objects

The last of the four basic forms is the cone. Probably the first object that pops into your mind is an ice cream cone. But there are bottles, glasses, lampshades, bowls, and many other man-made objects with shapes based upon a cone. There are also countless creations of nature—sea shells, flowers, and trees—with conical shapes.

When you begin to draw conical objects, remember that a cone is a solid mass that tapers uniformly from a circular base to a point. Look for this form *first* in the object you're drawing, whether it's long and thin like a beer glass, or short and broad like a lampshade.

## SYMMETRY OF THE CONE

The best way to draw a symmetrical cone is to begin with a center line. Then draw the ellipse at right angles to this center line. Mark the place on the center line where the tip of the cone should be, depending on its height. Having established the base and the tip, it's a simple matter to run two diagonal lines from the tip to the ends of the ellipse to form the basic cone. (See the demonstration at right.) Now you can begin to add the details that pertain to your particular object.

## DRAWING EVERYTHING

Draw as many conical forms as you can find. When you're finished with the last demonstration in this section, you'll have achieved a great deal. It's really a fine accomplishment to be able to draw—in their correct proportions—all the objects suggested here. If you've mastered the four basic forms, you can draw anything in existence. Imagine!

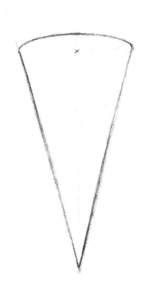

**1.** The artist began by drawing the entire geometric cone. Notice the line drawn through the cone's center. The artist used that line to help him establish the proper proportions and thus, the cone's symmetry.

**2.** Having established the dimensions of the cone, the artist departed from the geometric form by adding detail. The detail transformed the geometric shape into a recognizable object, an ice cream cone.

**This sea shell has two cones forming its construction. In order to achieve its proper proportions, you must ignore, at first, the shell's rather elaborate detail. Here the artist has indicated the two cone forms and their relative positions within the large sea shell.**

# Composing Objects with Basic Forms

Now the real satisfaction and consequent enjoyment of drawing begins. Since you can draw all the basic forms, you can begin to put them together; now you'll be able to draw any object you wish. No matter how complex your subject may be, drawing it is only a matter of combining basic forms.

## BASIC FORMS AND THEIR RELATIONSHIPS

You must arrange your basic forms—whether complex and composed of many parts, or simple and made up of only two—so that they *relate to each other* in both size and position. The same questions you asked yourself when observing and drawing an object

composed of a single basic form should also be asked when you draw a complex object. How high, how wide, and how deep is one basic shape in relation to another?

Search for the proportions of your basic forms with many lines; don't erase any of them. In this way you'll be able to compare and contrast proportions and establish correct shapes. Once you have the general proportions correct, you can place a fresh sheet of paper over your subject and clean up your drawing.

## DRAWING SYMMETRICAL OBJECTS

Establishing the symmetry of such objects as glasses, lamps, or can-

dlesticks is vital to attaining their correct shape. Draw the center line through your object as the artist has done (see below). Next, draw the left contour of your object; then flop your drawing over. Register your center line and trace the contour of the right side from your left one onto another sheet of paper. Both sides of your object should now be perfectly alike—symmetrical. Then, taking still another sheet of paper, trace the entire object and refine your drawing by eliminating any incorrect lines.

## DRAWING AND OBSERVATION

You can draw anything. With the four basic geometric shapes, the possibilities open to you are endless. But you must be able to carefully discern the basic shapes that are underlying objects. Sometimes they'll be almost totally obscured by a wealth of detail; sometimes one object will be composed of so many individual basic forms that it will be difficult to distinguish each separate form.

Therefore, you must sharpen your visual powers. You must do more than see, you must observe. You must learn to think about what you're viewing and ask yourself basic questions concerning an object's relative proportions and dimensions. Observation will play an important part in your drawing as you draw objects in relation to the horizon, that is, as you draw objects in perspective.

**This pitcher is made up of only two basic forms: the sphere of its body, and the cylinder of its neck, base, and handle. With all its detail, this cruet seems more complicated than it actually is. It's composed of only three basic shapes: cone, sphere, and cylinder.**

# DRAWING LANDSCAPES

When you start drawing the landscape, you must begin to see it in terms of *values*—not lines. There is no reason why you, as an artist, cannot change the values you see before you. A musician will take a group of notes and bring them together in such a way to make harmony, and they become a beautiful piece of music. So you will take a group of subjects—a farm, trees, mountains, boats, etc.—and bring them together to make a composition. This will take some planning and arranging. In this section you'll learn how to see the landscape as values and vignettes, and how to draw from photographs.

# Creating Textures with Lines and Strokes

As you start to draw from nature, you will want to indicate textures such as stone, wood, grass, shingles, etc. Not only will this give your drawings authenticity, but it will also add liveliness and interest. Remember, however, that you are not copying an object, but indicating it—this means that you do not want to strive for a photographic copy, but, you do want to combine values and strokes to simulate the quality of the object's texture. When lines and tones are combined, you achieve the patterns necessary to draw convincing subjects (see below and following page). Creating textures with the use of lines, not tones, is shown here: A jagged line (A) using a vertical motion and varying the pressure. A jagged line (B), but using only a horizontal movement, also varying the pressure. Large, curved, continuous line (C) with a rounded point. A finger line (D), small curves, varying the pressure. Long arcs (E), dark with pressure, small areas changing direction, and lighter pressure. Short, curved strokes (F) from bottom to top, and varying the pressure and direction. Longer, curved strokes (G) from bottom to top, combined with long arcs. Short, straight strokes (H), slightly varying the direction. Very short strokes (I), becoming wider apart, shorter, with less pressure as it gets lighter. Jagged, vertical strokes (J) moving down and then back up without lifting the pencil from the paper. A continuous jagged line (K), varying the pressure. Very short strokes (L), becoming longer, and using more pressure as they get darker. Short strokes (M), varying the pressure from left to right. Long irregular lines (N), flat point, with less pressure on the right. Short angle lines (O), varying the pressure, moving from top to bottom.

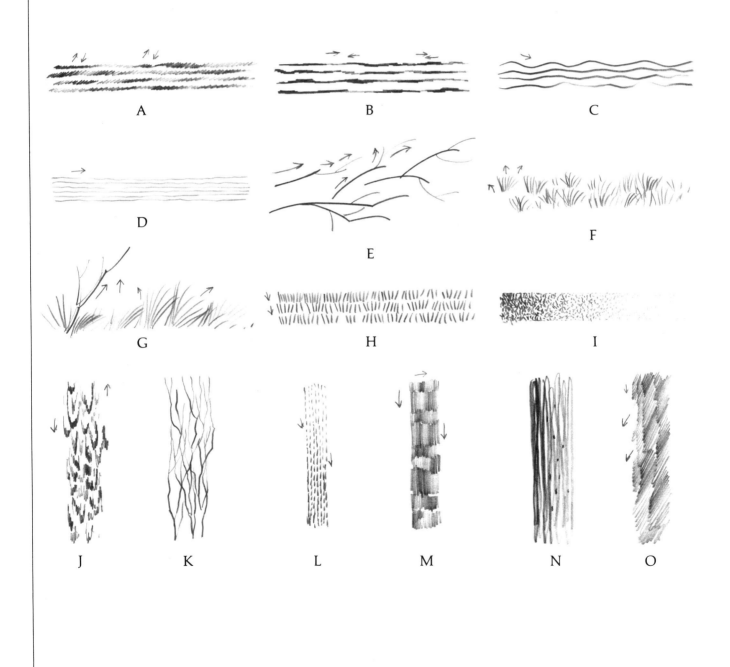

Here is a closeup demonstration of how various strokes and combinations of strokes can be used to indicate the textures of shingles, grass and trees. Don't try to draw a complete picture, but pick out close-up views of different subjects.

  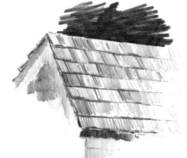

Shingles made with a combination of strokes from the previous page: (O) short angle lines, varying the pressure, moving from top to bottom; (M) short strokes, varying pressure from left to right; and (B) a jagged line but using only a horizontal movement, also varying pressure.

Grass in the fields made with strokes from the previous page: (F) short, curved strokes from bottom to top, varying the pressure and direction; (H) short, straight strokes, slightly varying the direction; and (E) long arcs, dark with pressure, small areas changing direction, and lighter pressure.

Tree trunk using strokes from the previous page: (O) short angle lines, varying the pressure, moving from top to bottom; (J) jagged, vertical strokes moving down and then back up without lifting the pencil from the paper: and (E) long arcs, dark with pressure, small areas changing direction, and lighter pressure.

# Seeing the Landscape as Values

Suppose you are drawing a gray barn of the 5th value against a mountain of the 4th value and a foreground of the 6th value. If you make all the values as they are, it will be a pretty monotonous drawing. (If you are having difficulty with values, review the value charts on pages 12–13.)

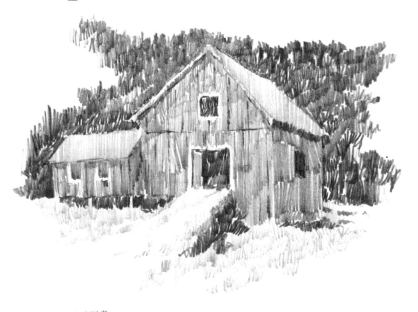

Now start to change the values. Make the barn a 7th value, the mountains a 3rd value, and the foreground a 5th value. Notice how you are now getting some separation and interest.

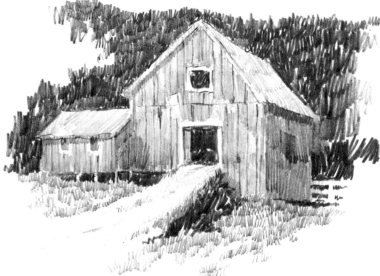

Go a step further and make the barn a 10th value, the mountains a 0 value, and the foreground a 5th value. You now have the widest range of values possible. There are a variety of value arrangements you can make in any drawing. It is up to you to decide where you want the emphasis and what effect you want to achieve.

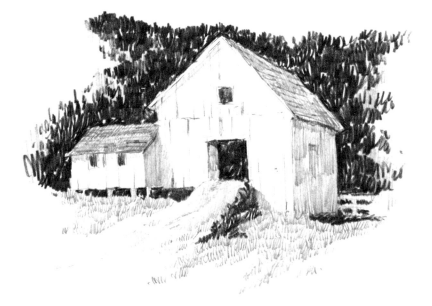

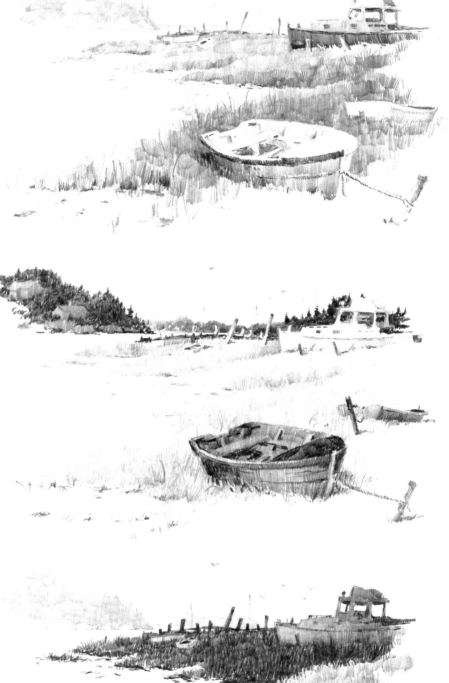

## EAST GLOUCESTER
In this drawing the values are exactly as the artist saw them. The values are the darkest in the foreground and lighter in the distance. He drew this one on the spot.

This is the same scene as above, but here he changed the values. He changed the background from the lightest to the darkest value. Notice that by changing values, you can obtain a different emphasis. There is never only one way for values to be correct. Experiment by changing the values until you arrive at the most effective composition.

Again, the artist changed the values. This time he made the middle distances the darkest value. This arrangement is not as effective as the other two, since it gives an unnatural change of values. There should be a cloud that casts a shadow over that area, but it is not too likely.

# Building Your First Drawing

The subject of this demonstration is relatively simple, but it does include different kinds of textures—wood, stone, shingle, trees, and grass. These surfaces were all rendered in a different manner.

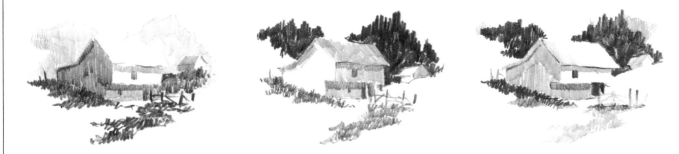

### PRELIMINARY VALUE STUDIES

In the first drawing the artist made the values exactly as he saw them. There are light trees in the background, and dark dirt and grass in the foreground. A strong light from the right strikes the front of the barn. This isn't good, since the dark side of the barn and the foreground all run together and the light side of the barn and background do the same. In the middle drawing, he made the background trees the darkest value. To separate the dark side of the barn and the foreground, he changed the light so it comes from the left.

This still isn't appealing because the light side of the barn is flat and uninteresting, yet it has become the focal point of the drawing. In the final sketch the artist kept the background trees dark, since this creates a good sharp silhouette of the barn. He preferred the light coming from the right, the way it actually appeared. He kept the middle tones in the shadow side of the barn and under the eaves in the front, and the light values in the foreground. This creates a nice simple pattern of lights, middle tones, and darks.

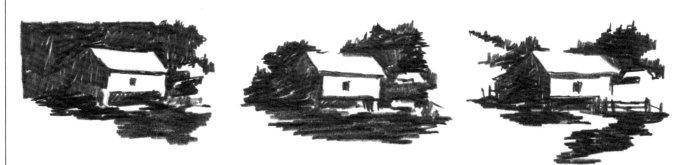

### PRELIMINARY VIGNETTE STUDIES

In these studies, the artist was concerned with working out the basic shape of the vignette. His first thought was to square off the top and left side of the barn, since it faces right and the light is coming from that direction. Because the barn has many square corners, he thought it would be more interesting if there was a softer vignette around it, so he drew another one.

The shape of the second vignette has too much of an overall solid feel because the artist didn't use any white areas to break it up. The left side of the barn awkwardly converges

with the background, and the foreground is flat and dull-looking. He did another drawing.

The final vignette is much more successful. The outside shape has a definite feeling of space and dimension and there are some interesting minor silhouettes created by the fences against the white area. The path in the foreground leads your eye directly to the center of interest.

With the values established and the vignette achieved, the artist was now ready to start the drawing.

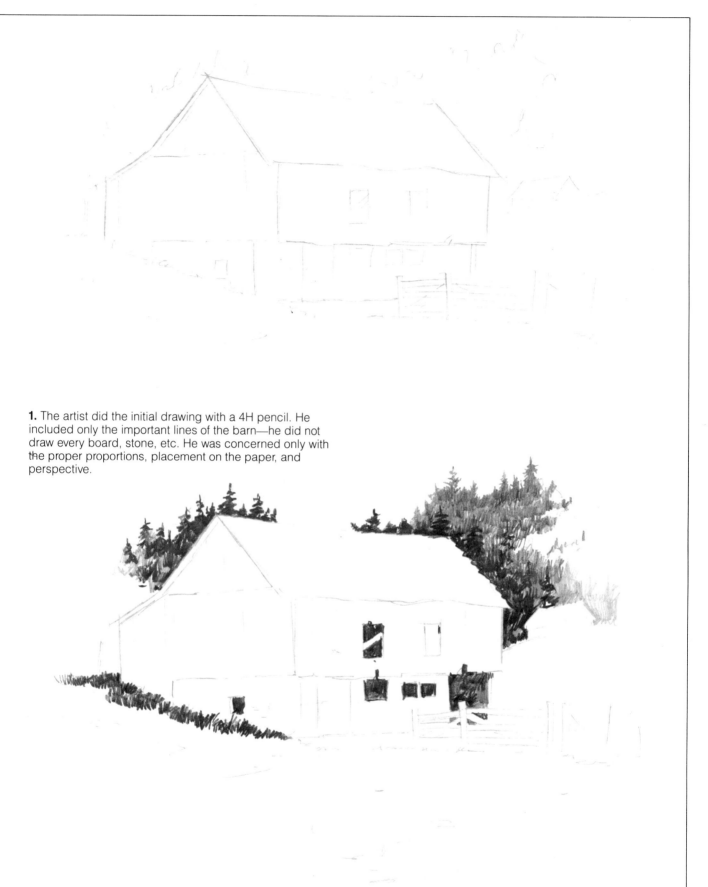

**1.** The artist did the initial drawing with a 4H pencil. He included only the important lines of the barn—he did not draw every board, stone, etc. He was concerned only with the proper proportions, placement on the paper, and perspective.

**2.** He established the darkest tones first, using an HB pencil. Then he made the trees behind the barn one value darker with a 2B pencil. There is a basic reason for starting with the darkest areas. The light area is pretty well established. You cannot go much lighter than the white paper or possibly one value lower with a 6H pencil. The two unknown values that were established later were the middle and dark tones. When he laid-in the darkest first, he immediately established how dark he was able to go with the middle tones. The middle tones are always the critical areas. If they are too dark, the drawing will become too low-key, and if they are too light, the drawing will look washed out.

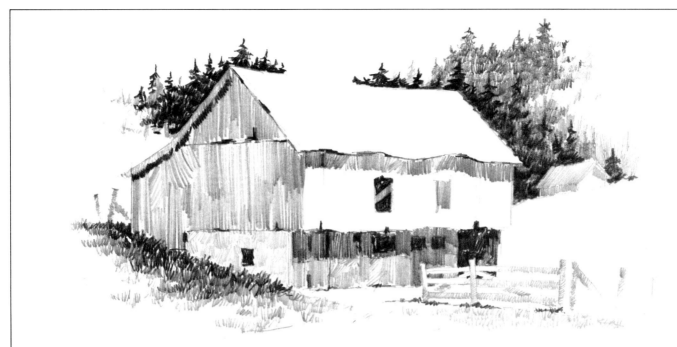

**3.** Once the darks were established, the artist put in all the middle tone areas. Since the boards on the side of the barn were vertical, he drew all his strokes the same way with a 2H pencil, varying the direction occasionally to add interest. The stone area (left), the fence, and the beginning of the grass were added with a 4H pencil. With an HB pencil, he darkened the shadow from the overhang on the front of the barn. He added details only after he was satisfied with all of the value areas.

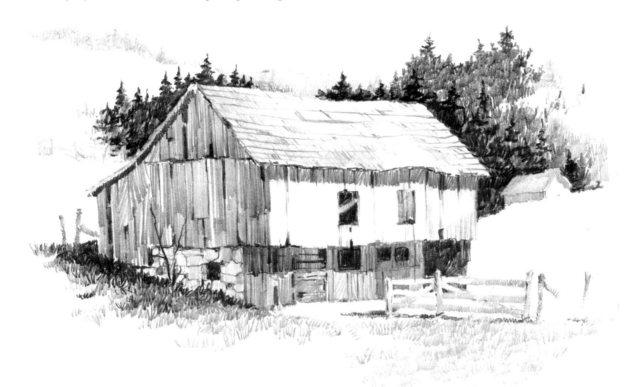

**4.** After all the values were laid-in and the vignette established, the artist began working on the detail and the texture. He drew some of the boards on the shadow side of the barn with an HB pencil. To add interest, he indicated some of the boards missing. The artist felt that this was a case where he needed to exercise a little artistic license. Even though there were no boards missing, he felt that the barn would look too boring if he left the sides as they were.

With a 6H pencil the artist indicated the right edge of the barn, and he used a 2H pencil to add the missing boards.

Notice that the details in this area were left to a minimum. If he had indicated too much detail, it would have cut the value down and reduced the effect of the light on the front side. Finally, with a 6H pencil the artist indicated the roof, hills, and trees in the distance, and he finished the grass in the foreground. He then placed the drawing in a mat and moved away from it to see if the values held together from a distance. With all the visualizing, preparation, and planning, he completed the drawing in approximately one hour.

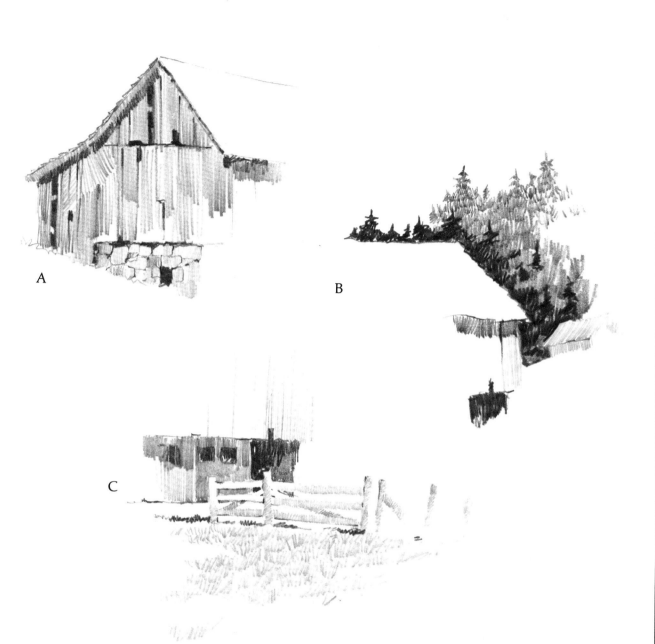

## STUDIES OF THE FINISHED DRAWING

**A.** The side of the barn was drawn quickly with a 2H pencil using vertical strokes and varying the amount of pressure. This gives a slight tonal change that occurs in barn siding. The artist did not go from the top to the bottom in one stroke. He changed the length and direction of lines, again giving more interest to the area. After he put in the divisions of the stones with an HB pencil, he darkened an occasional stone with a 2H pencil.

**B.** The trees in the background were indicated with very short strokes going in all directions. He covered the entire tree area with an HB pencil, and again, using very short strokes, he used a 2B pencil to draw the darker trees next to the roof of

the barn. Notice how the value relationships are quickly established with the dark areas against the white paper.

**C.** The fence was indicated with a 4H pencil. The strokes are vertical, but note how the direction is slightly varied. The artist left the fence white in front of the dark area of the barn. With a 4H pencil, he drew the grass with short strokes going in all directions.

Observe how the fence is not outlined. The entire fence is held together by tones. On the right, the fence is indicated, and on the left the dark background constructs the fence. *This is important*: Do not outline objects and then fill them in with a tone—that will make your work look amateurish.

# Creating a Dark Value Pattern

The flat rendering (right) of the "Lobster Shacks" drawing shows how Ferdinand Petrie planned his values with three pencils. The darkest value was drawn with a 4B pencil, the dark middle tone with a 2H pencil, and the light value with a 6H pencil. Try to visualize all your drawings in as simple a statement as this diagram. Notice also how he planned the vignette with white areas coming into the drawing.

In the finished picture the artist showed how dark values can lead your eye through a picture. The dark rocks in the foreground lead the viewer's eye into the cast shadow on the wall, then through the center shack, and finally into the dark tree. All other values and the vignetting lead to this central pattern of darks.

# Smudging the Pencil

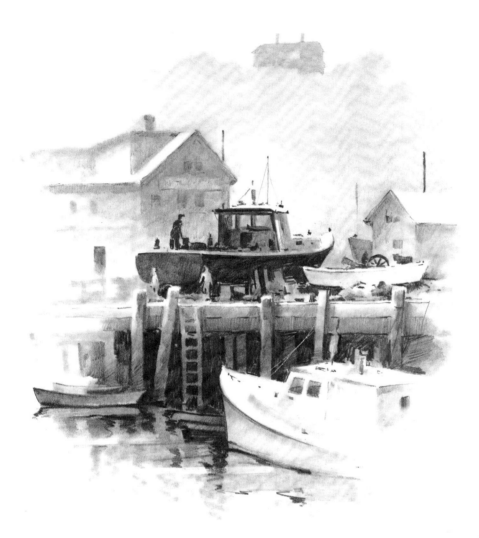

### SMUDGING EFFECTS

This drawing, done in Ferdinand Petrie's studio, illustrates the effect you can get by smudging the pencil. He used a 2B pencil, varying the pressure, and then used a paper stump for smudging. Many of the lighter tones were done with the stump itself.

At right is the same drawing done on-the-spot. He used 6H and 4H pencils for the light values, 2H and HB pencils for the middle tones, and a 4B for the dark tones. The artist feels this drawing has a much nicer quality because the individual strokes can be seen.

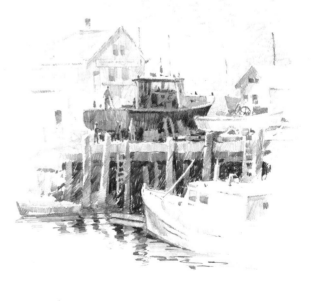

# Drawing a Harbor Scene

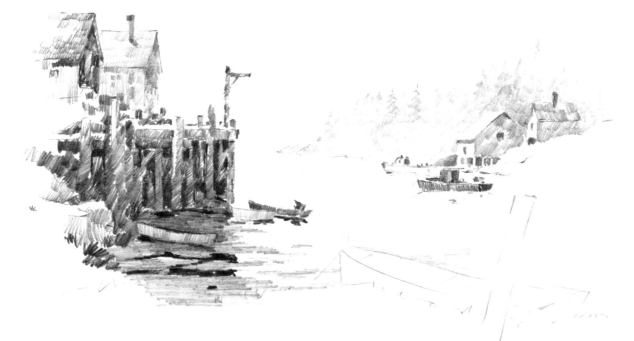

**1.** Simplify the harbor scene—if there are 200 boats in the harbor, don't try to indicate 199 of them. Select a few that make an interesting pattern and forget the rest. It is also a good idea to draw a moveable object first. There is nothing more frustrating than to be half-finished with a harbor scene drawing and have the boats leave. The shacks, docks, and trees will always be around, but the fishermen have a habit of moving their boats at the wrong time.

In this harbor scene, an early morning fog had set in, so the artist decided to keep all his darks in the foreground, with a white sky and water and middle tones in the distant shore.

He laid-in the entire scene with a 4H pencil, and left out many boats that were moored in the harbor. With a 6H pencil, he indicated the distant shore line and left the tall fir trees as a silhouette. He lightened the pressure on the pencil as he moved to the waterline to give a graded value to this area. To indicate the trees, he used short strokes, and made a few darker so that they could be recognized as trees. He rendered the shadow side of the shacks in the distance with a 4H pencil. The window and the darks under the shacks are spotted with a 2H pencil. Notice that the value range in this area is from 9 to 7, using a 6H pencil to a 2H pencil.

**2.** The artist indicated all the darks with a 2B pencil, including the dark house, the space between the poles in the pier, and the reflection in the water. Using an HB pencil, he put in all the middle tones of the pier, and with the same pencil, he used horizontal strokes to put in the foreground mud. He applied more pressure closer to the base of the pier,

to make the base of the pole blend with the mud. The roof, the side of the left shack, the other shack, and the boats, were all rendered with a 2H pencil. The strokes on the boats are vertical, following the shape of the hull. The range of values in this area are from 7 to 4, using 2H to 2B pencils.

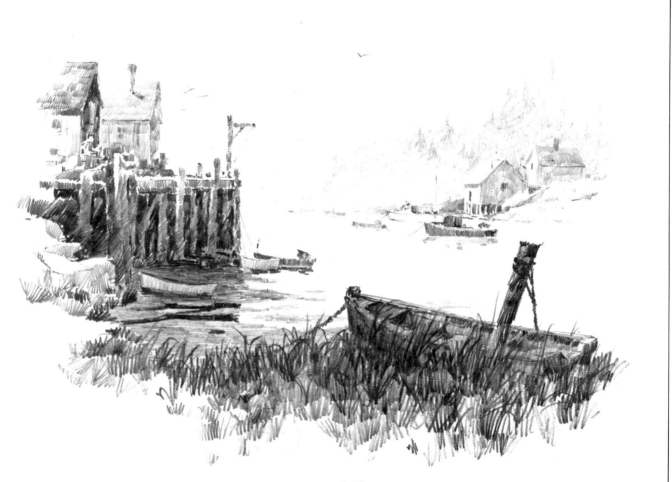

**3.** The artist drew in the foreground grass and boat with HB and 4B pencils. He wanted this area to be dark with little detail. He added the rope from the pole to the boat so the pole would not "lean out" of the drawing. He then placed the gulls in the sky with a 2H pencil. The values in the foreground are from 4 to 1, using HB to 4B pencils.

A

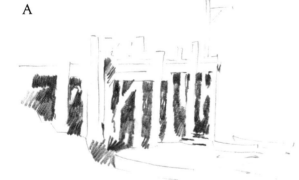

B

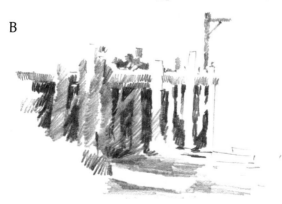

### STUDIES OF THE HARBOR

**A.** The area under the pier can become very confusing. If the value difference of the poles and the darks between them is not too great, the pier will hold together as a unit. The artist put in all the darks first with a 2B pencil. Notice that the strokes are short and occasionally change direction. It isn't necessary to have sharp edges on the poles—you can let your edges be ragged.

**B.** Once all the darks were indicated, the artist filled in the poles with an HB pencil. These lines go right over the darks he put in with the 2B pencil. Keep this area loose; don't have sharp edges or wide value changes.

# Drawing Reflections in Water

You can become confused with so many rules about reflections; however, a few basic observations should be noted.

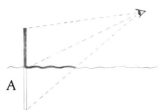

In A., you see why the reflection of a pole that is straight in the water should be at least as long as the pole itself.

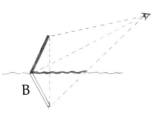

If the pole is leaning toward you, B., the reflection will be much longer than the pole appears to you.

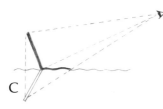

If the pole is leaning away from you, C., the reflection will be shorter than the pole. A pole is used here as an example, but this principle applies to the side of the boat, a tree, a house or any reflected object.

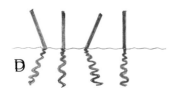

In D., notice how the reflection leans to the same side as the pole leans. If the pole leans to the left, the reflection will lean, from where the pole goes into the water, to the left. All verticals will reflect straight down, no matter how many there are or how wide apart.

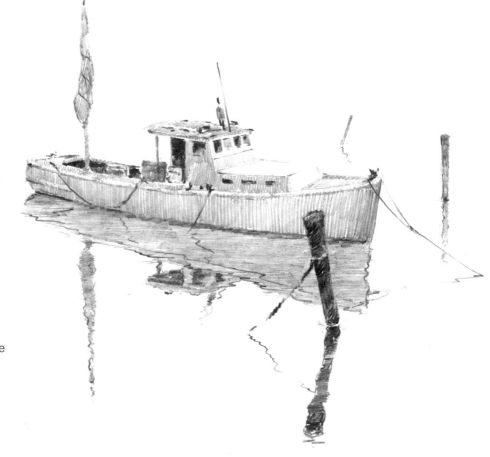

**1.** In an enclosed harbor the water often will become as smooth as glass. The boat in this drawing is in water that has very few ripples. Many mistakes are made in thinking that reflections are a reverse of the object. Notice in the drawing that the reflection is not simply a tracing of the boat turned upside down. You are looking down at the boat, but in the reflection you are looking up. For example, you can see the top of the cabin, but in the reflection you see underneath the roof of the cabin. Water is drawn with horizontal strokes to achieve flatness and perspective.

**2.** As the surface of the water becomes broken by the wind or a moving object, it distorts the mirror-like reflection.
E. How dark or light the reflection is depends upon where the sun is hitting the object. If the side of the boat is in shadow and the sun is hitting the top of the water, the reflection will be lighter than the boat. If the sun is hitting the side of the boat, however, the reflection will be darker than the side (opposite page, top right).

F. When the water is disturbed, it makes a series of hills and valleys. The sky is reflected in the hollows. This breaks up the solid form and makes the reflection longer (opposite page).

**3.** When the wind causes the water to break up into many small ripples, the reflection is lost. There is, however, a diffused area in the water under the boat.
G. Notice how perspective is involved in drawing water and reflections. The further the water goes away from you, the less distance there is between the ripples. The same rule applies where the reflections are more definite. The reflection near the base of an object is condensed, and it spreads out more and more as it comes toward you (opposite page).
H. Most of the time the reflection of a black boat will be lighter than the boat itself. This is due primarily to the fact that no matter how dark the reflection, it will become lighter due to the transparency, the density, and the color of the water (opposite page, bottom right).

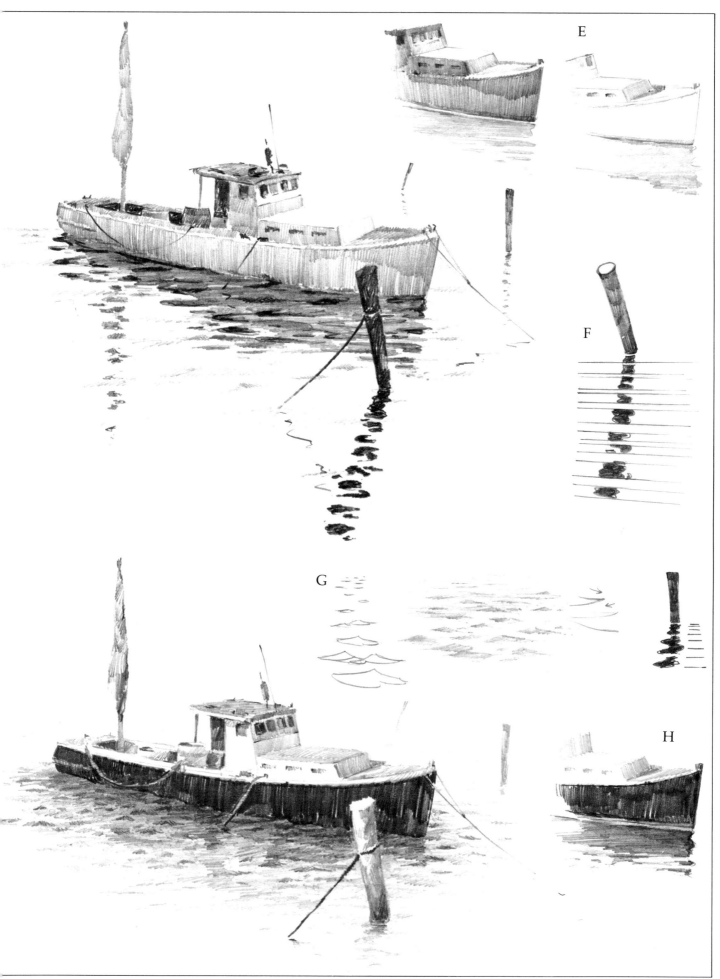

E

F

G

H

# Simplifying a Busy Scene

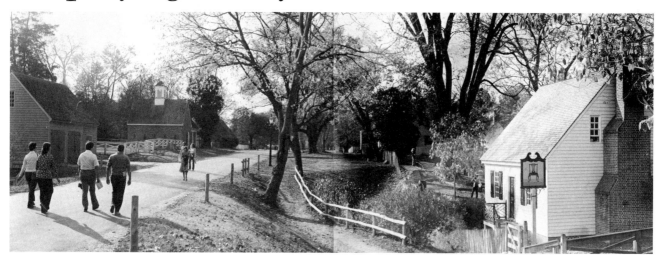

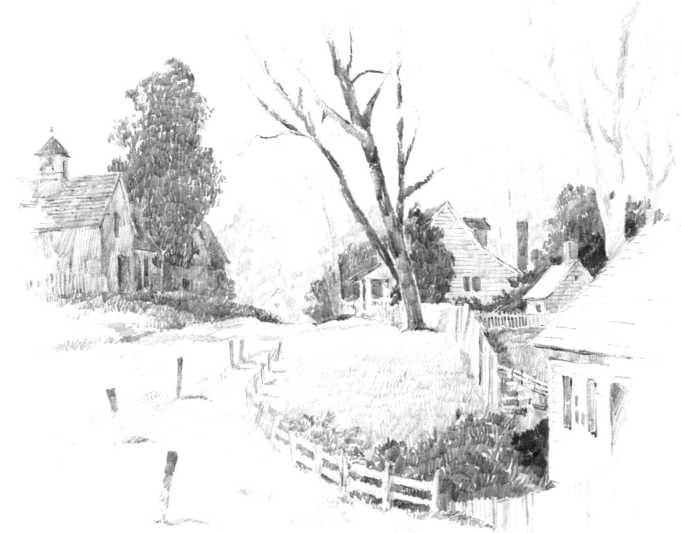

Here is an example of a very confusing scene. Too many trees create a diversion that cuts the scene in sections. The artist eliminated most of the trees along the road to avoid cutting the drawing in half. He left a few trees in the background around the house. The artist felt the road would look more interesting if it was going over a hill, than just left flat. He left the posts along the road to bring the viewer's eye into the picture. The posts and the fence give the scene some movement in the foreground. An interesting perspective problem results; the house on the right is below eye level, while the rest of the drawing is eye level or above. This area was minimized since it would look too confusing otherwise.

# Adding Interest to a Flat Landscape

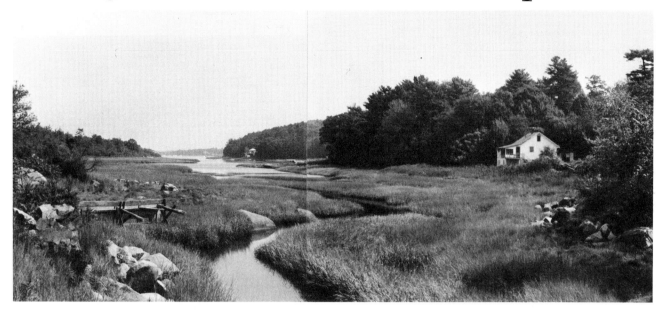

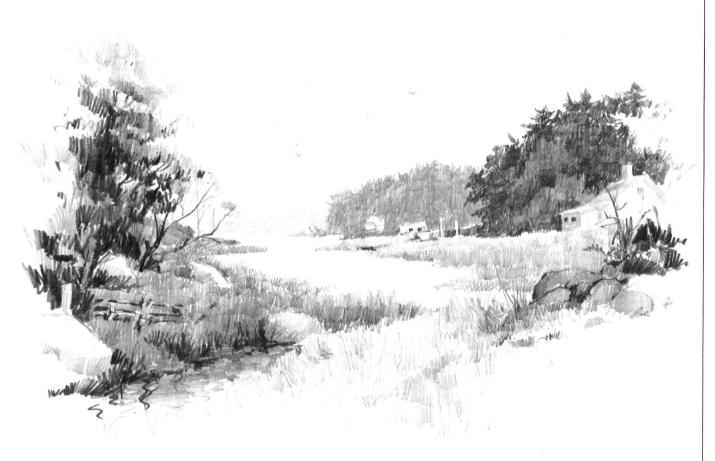

Salt marshes and meadowlands make interesting subjects for drawings and paintings. The flatness of the land and the water snaking through the grass make it easy to guide the viewer's eye into the drawing. Although long pictures can be interesting, the artist feels there is often too much area of no interest. To avoid that problem in this scene, he moved the house on the right into the picture, eliminating most of the

large tree bank. To make the water the center of interest, he shortened the left side also. This is a good example of aerial perspective. He made the tree bank furthest away an eighth value, but the foreground trees are darker in value. The house on the right becomes important because of the strong contrast between the light house and dark trees behind it.

# Interpreting a Cluttered Scene

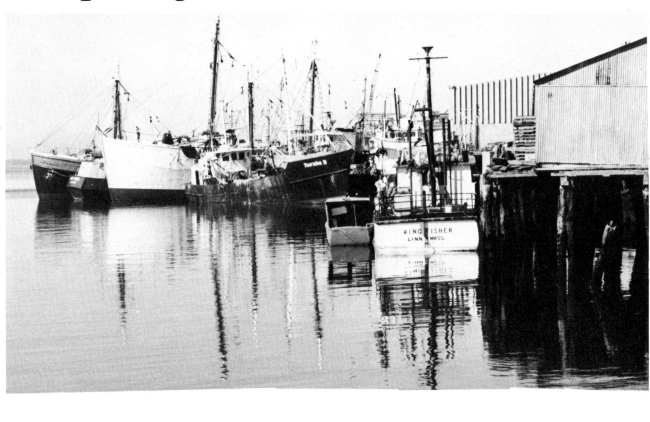

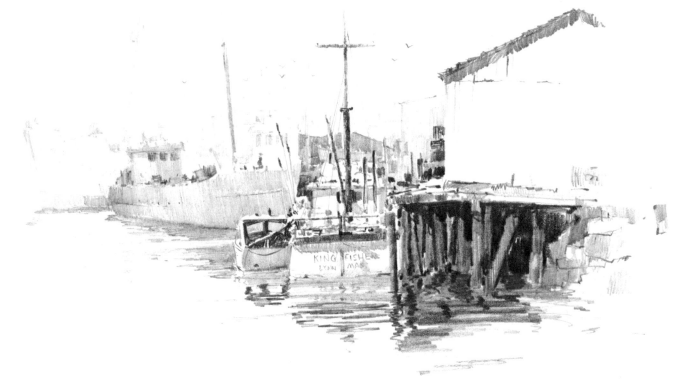

This is a case where there were just too many boats. With a maze of masts, hulls, lines, reflections, buildings, and fishermen, it was difficult for Ferdinand Petrie to know where to start. He knew immediately that he could not include everything; so he concentrated on the buildings on the right and the two small boats tied to the pier. He faded the rest of the boats and eliminated the last two on the left altogether.

He used all of his darks in the foreground and left out all the texture on the building for a better vignette. He simplified the reflections and gave a simple treatment to the water. A scene like this can be overpowering if you try to include everything you see. Put all your effort into a small area and make that as interesting as you can.

# Creating a Center of Interest

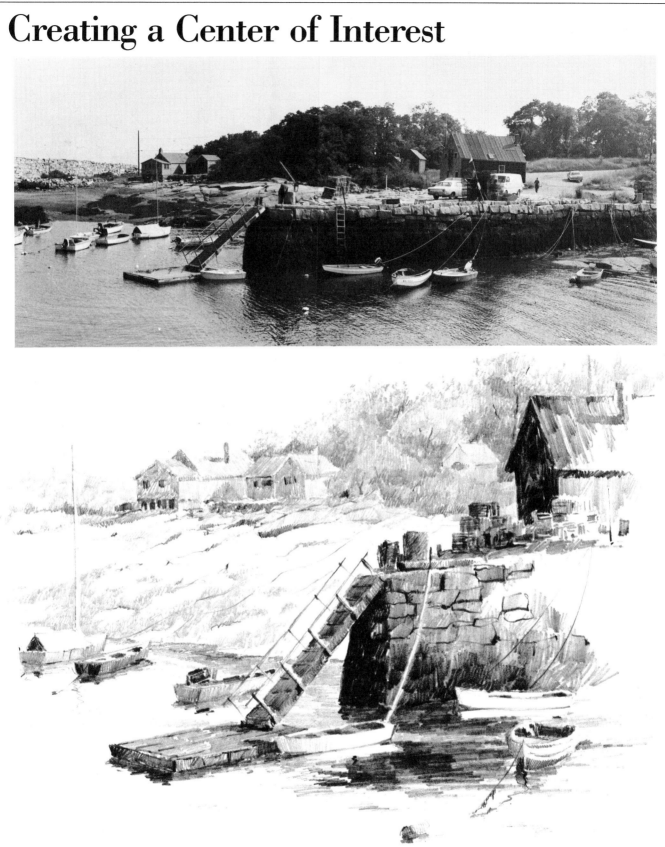

Ferdinand Petrie struggled before deciding to make the end of the fishing pier his center of interest for this drawing. The long flat rocks with the boats and houses would have made an interesting subject. He also felt the floating dock and stone pier were important, and the large shack and trees in the background could make good subject matter. Care had to be taken because there were actually three drawings that could have been made of this one subject.

To use the end of the fishing pier, the artist subdued all of the elements around it. He lightened the entire area, drawing enough detail in order to see what was going on. This made the end of the stone pier become a silhouette. He kept the shack dark in value, but moved it closer to the end of the pier so it became a unit. Since he did not want to draw all the boats, he left only enough of them to create the feeling of an active harbor.

# Developing Dark Values

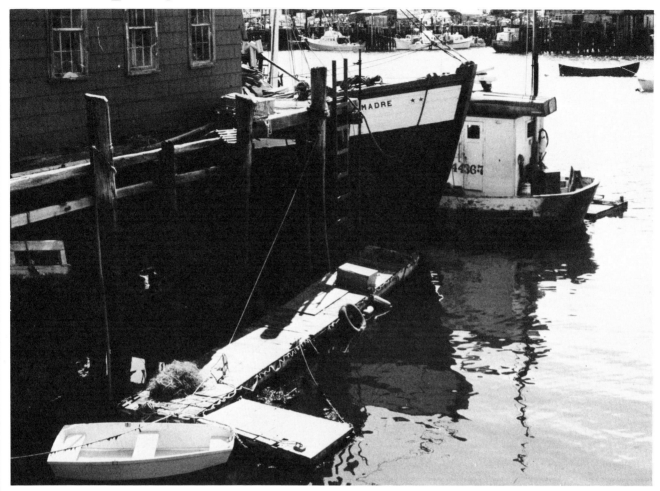

In this drawing the artist had a problem with the sun. The only position he could take to make the painting work was to look directly into the sun, which made the larger boat, the reflections, and the pier area very dark. He decided to maintain that effect, so he kept the dark values in the same pattern. By making the distant shore very light in value, he didn't interfere with the silhouette of the boats. An additional element was introduced with the dock and the boat in the foreground. Because the complete dock and the boat were too far from the larger boats, he shortened the floating dock. This made a better composition since it brought all the elements of the picture together.

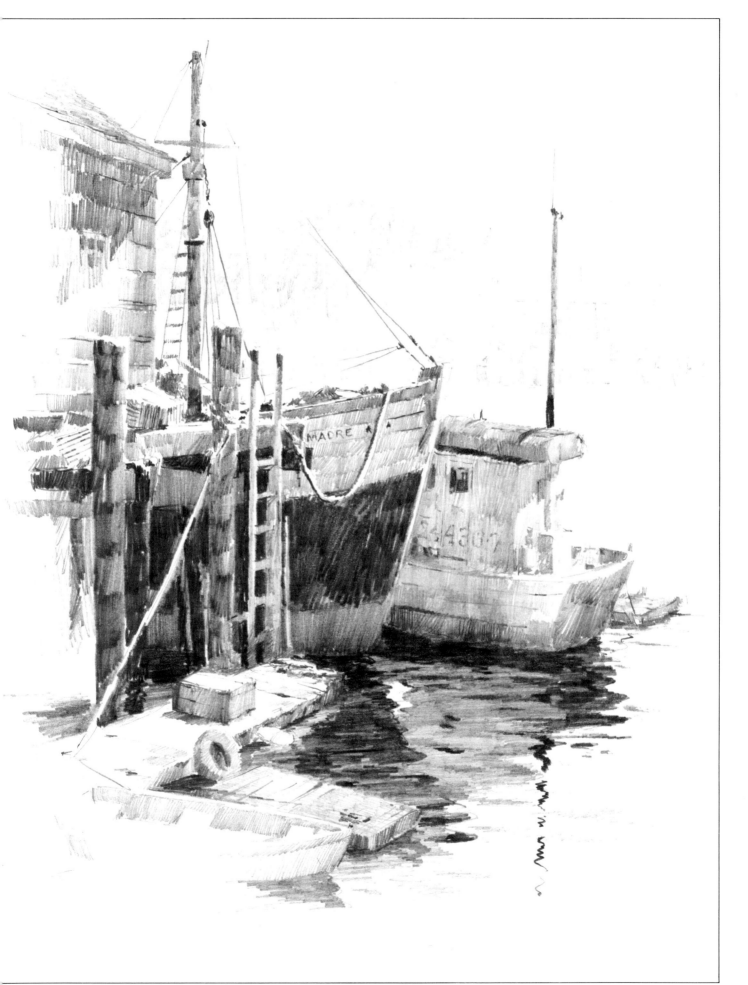

# DRAWING PORTRAITS

Using the pencil to get a likeness is a great challenge for the portrait artist. Simply because of its pointed precision, pencil encourages a greater interest in the details than in the whole. A case in point is around the eyes, where artists' fingers often irresistably make precise pencil marks. It's excusable to pick out some details just for "navigational" points, but it's best to keep moving to other parts of the portrait. Starting with a close-up analysis of the eye, this section shows with step-by-step instructions how to successfully develop a portrait drawing.

# Drawing the Eye

The eyes are the most significant facial feature in a portrait. They convey so much of a person's feelings and personality. Portraitist Douglas Graves describes the best way to draw the eye below.

In the three demonstrations that follow, notice that the artist used tone rather than line in rendering the steps. In a smudgy way, he attempted to convey the depth of the eye in the socket, the roundness of the lid, and the dark presence of the pupil. To suggest sparkling eyes, try a black carbon pencil on a middle-tone gray pastel paper. He next used white pencil to develop the planes further and to establish the whiteness of the cornea. He also indicated which would be the lightest areas (such as the corner of the eyelid) and which the darkest (in this case, the pupil). In the final stages, he strengthened the values, darker or lighter, and then added details and highlights.

### FRONT VIEW

**1.** Using a B pencil, the artist started the eye by smudging in a round, darkish cornea, around which he would later build the rest of the structure. Here the upper lid rested right on the cornea, actually covering about a quarter of it. The artist molded the lower lid in a deep curve, forming the boundary between the eye and cheek. Both of these lids were shaded to suggest the circularity of the eyeball underneath. The eye was also shaded near the bridge of the nose and at the outer eye corner. A few quick lines already show where the eyebrow will lie.

**2.** First, the artist established the tonal spectrum—using the darkest black in the pupil, and white pencil in the cornea. Next, he corrected some of the eye proportions. He raised the arch of the upper lid so that it just touches the outer limit of the pupil, which is about half the area of the whole cornea. An attentive, alert eye will have this arching shape. Also, he closed in the lower lid around the cornea and shaded in the eyebrow.

**3.** The artist used the tones of his spectrum to further define the eye. On the left side of the cornea, he used white pencil to emphasize the roundness of the eye. He left the right side the natural gray color of the paper, but he deeply shadowed the upper edge and outer corners of the lower lids. He heavily shaded in the crease above the upper lid and added lashes to both lids. He used long, outward-sweeping lines for the upper lashes, and short dashes for the lower ones.

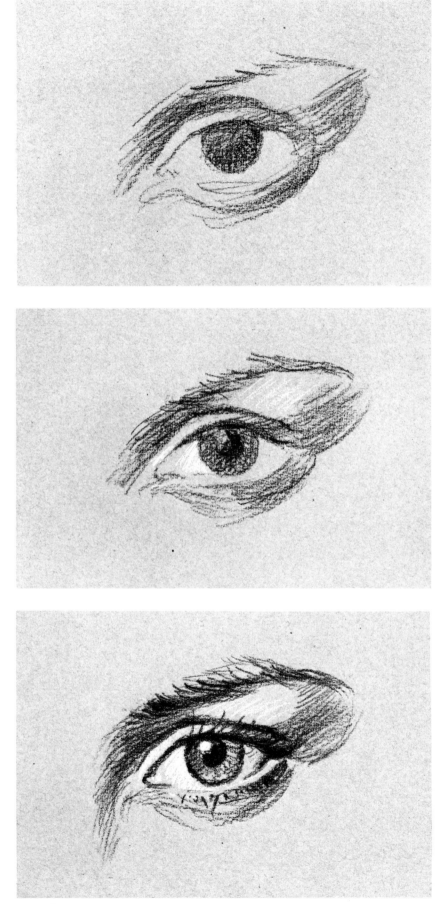

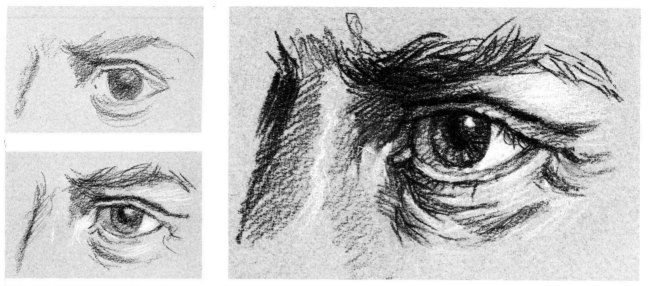

## THREE-QUARTER VIEW

**1.** As before, Douglas Graves started by drawing the cornea. He then sketched the lids and a suggestion of the nose. He indicated the basic tone of the eyebrow and positioned it close to the eyes to give a masculine appearance.

**2.** He established the extreme lights and darks, using white pencil and pressing hard with the black one. He accentuated the elliptical shape of the cornea and pupil and then sketched in straggly eyebrows, laugh lines in the corner, and wrinkles under the eye. Remember, this is the testing stage; if any element doesn't work well, it can be erased since it's so lightly sketched.

**3.** In this step, the artist just added emphasis to what he'd already drawn. He strengthened the gray and white tones along the front of the nose, in the eye corner, under the brow, in the sagging skin below the eye, and on the eyeball. Note that it doesn't take very much white shading for it to be effective; he added just a few scratches here and there in the corner and around the lower lid. The strongest areas of white are at the outer edge of the eye and on the cornea. He made the eyebrow even more scraggly-looking with a few well-placed lines, and left the lashes sparse, with just a few at the top and bottom.

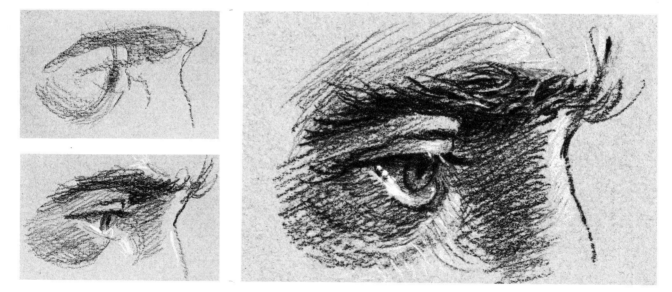

## PROFILE VIEW

**1.** The procedure is almost the same as for the front and three-quarter views, but since this was for a profile, the artist roughly outlined the brow, eyeball, and nose. This also was drawn as a man's eye.

**2.** Here the artist added tone to the sketch. Most of the structure around the eye is in shadow, especially the inner corner of the eye. He darkened the crease of the upper lid and rimmed the eye with lashes. Again, he used white pencil to add some fine wrinkles to the forehead, moisture to the lower lid, and shine to the nose. He drew wispy hairs into each eyebrow.

**3.** Because this was a profile view, the shadows were much darker, and so the artist shaded the drawing very heavily. On the side of the nose, he shaded around the form, giving it an illusion of smoothness.

He blackened the brow hairs and tried to sketch as great a variety of hairs as possible: long, short, straight, and curly. Then he used the white pencil to turn some of the black hairs gray. The eyelashes were both black and light gray, with the lighter ones resulting from the peculiar lighting situation. He also used the white pencil to show drops of moisture in the nearest corner of the eye. The cornea was not at all white here; since it was so much in shadow, the artist actually shaded the cornea with black pencil. Remember that such shadows happen often, and darken, rather than lighten, the eyeball accordingly.

# Drawing a Teenager

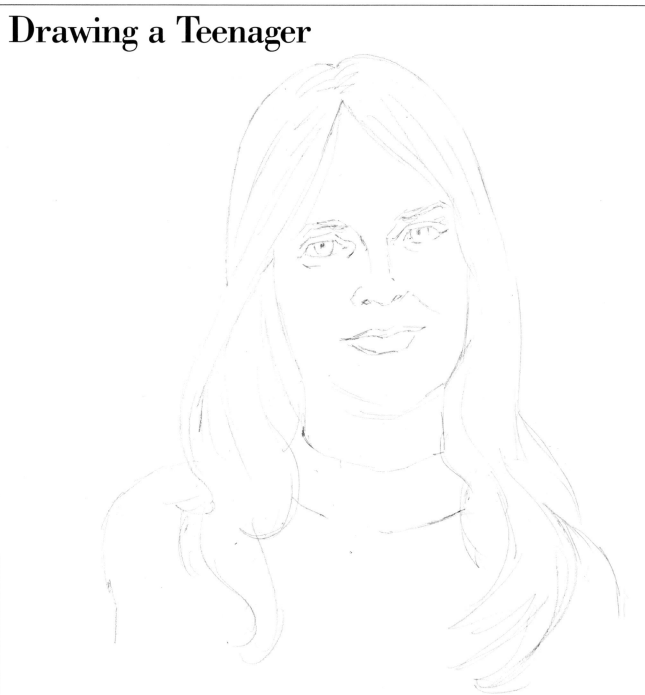

In this portrait of Cathy, the artist drew the face in light tones to portray a soft freshness. At the same time he avoided any slavishly smooth lines that might make the drawing hard and mechanical-looking. Long, straightish hair lends itself to swinging pencil strokes more than short hair does and the artist couldn't resist erasing out highlights on the hair to enhance it further. The strands hanging on each side reflect almost equal amounts of light, but they are different shapes and sizes.

A smile isn't necessarily an open, laughing mouth—it can also be just a pleasant, happy expression. The dimples are a consequence of this expression and are difficult to show unless they're handled with care. Remember that lines can show age and character—these dimples aren't meant for that purpose.

**1.** You could start your sketch the conventional way with a direct, precise pencil outline. However, you may want to try the technique Douglas Graves used for this drawing. Do an actual size preliminary sketch on a tracing paper pad with a medium-soft 2B pencil. If you should get off to a bad start or it begins to go sour, tear that sheet off, slip it under the top sheet, and use it to begin another one, making contours where necessary. When you get a drawing that is satisfactory, blacken the back with a 4B pencil and trace the outline on your illustration board with a hard 5H or 8H pencil. You might see some of the artist's traced lines in the drawing above.

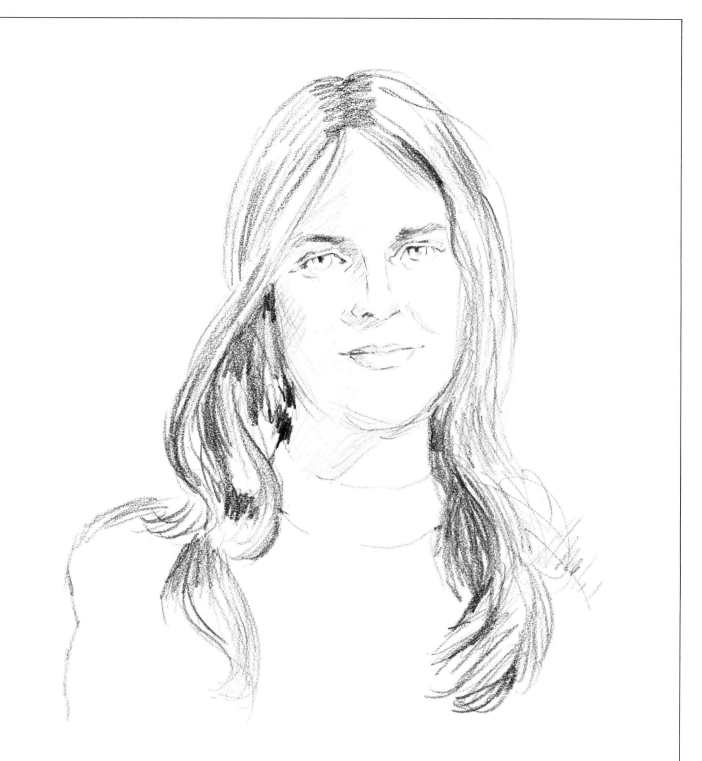

**2.** The artist stroked in some of the strands of hair with a 2B pencil, and he tried to give some semblance of form to the hair. He indicated a couple of dark areas next to the neck— these are the low key of the tonal scale in this drawing.

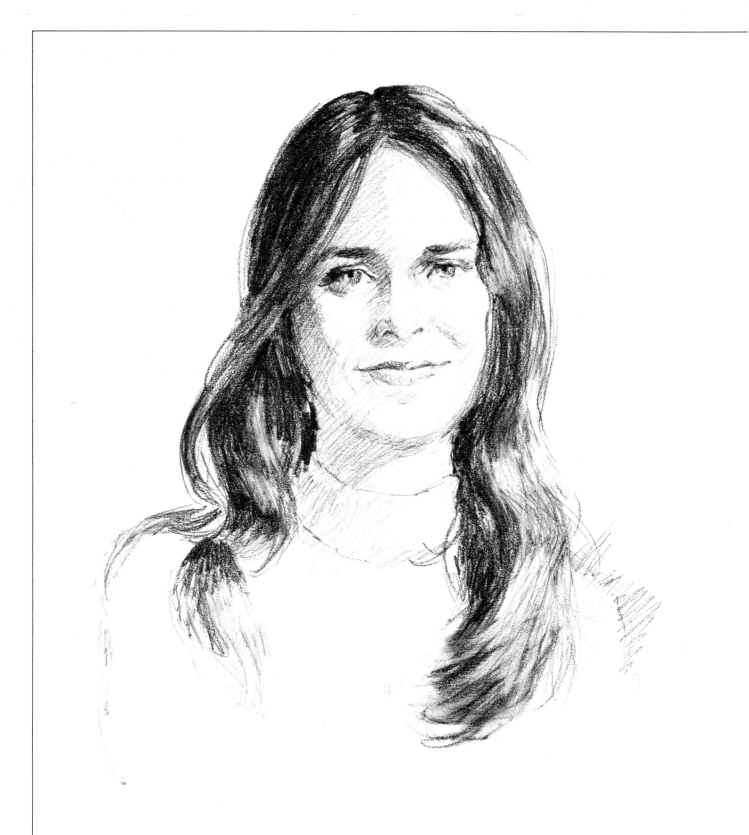

**3.** Here he worked on the hair, developing its light and shadow pattern. He started indicating the facial tones, and kept the skin surface smooth and softened the edges; he also darkened some areas around the eyes. The portrait has not yet been sharpened or defined, but you can still see the likeness emerging. At this stage, if the drawing wasn't quite right in spots, the artist could have simply made his changes where necessary to bring out the forms correctly.

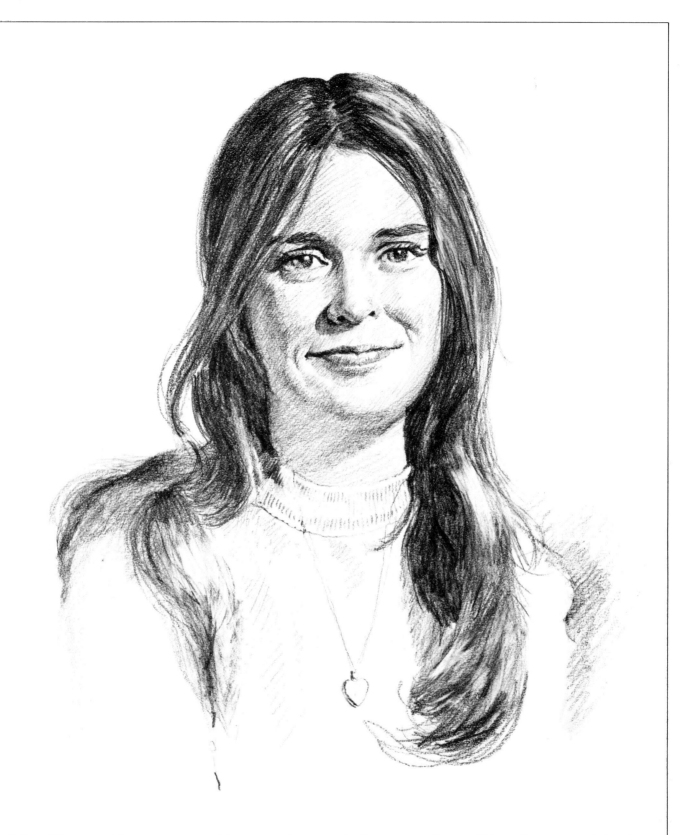

**4.** Everything started fitting into place at this stage, so he polished and smoothed the tones and sharpened the edges. He erased the neckline of the sweater to make the neck longer. He darkened the lines around the eyes and blended the two values on the forehead together. He used a 2H pencil for the lightest values—those which surround the highlights—on the forehead and the rest of the face, and a 2B pencil for the darker tones. Notice that the 2B lines are not an open

shading because they would have shown up as obvious lines and not tones, while the light 2H tones are open shading with definite lines, yet aren't as obvious. He finished the hair by softening some of the tones, especially at the ends of the strands. The artist tried shading in the background for atmosphere in a portrait such as this, but here it detracted from the head. He preferred the non-distracting background.

# Drawing a Man

As for the mechanics of this drawing of Oliver Rodin, a relative of the great sculptor August Rodin, you can see that the light comes from the windows in back of him, outlining his head and arms and shining through his white hair. Notice, however, that the hair tones around the forehead and ear appear rather dark, seeming to belie their true whiteness. The reason is that his hair doesn't have a smooth, planar surface like his shirt does, but instead has many tiny ridges and canyons formed by hair shafts. Therefore, the hair on the side cannot reflect a weak, indirect light as effectively as the shirt. So, unless the light shines directly upon the hair or through it, like at the top of the head, the hair often appears to be quite dark.

One problem here is the unity of the design as well as the correctness of the actual figure drawing, since the arms stretch away to a secondary object. The artist tried to counter the oblique line of the arms with downward, linear pencil strokes; he didn't want the strokes to be spaced too evenly, which would give them a machine-made effect, as in the shirt. He would have preferred developing the same loose feeling all over the face as in the arm, but then he wouldn't have been able to explicitly designate all the character planes.

**1.** The artist started this pencil sketch by carefully mapping out the portrait's tonal areas. He used a 4H pencil and kept the lines lighter than they are in this reproduction, since these had to be darkened for clarity.

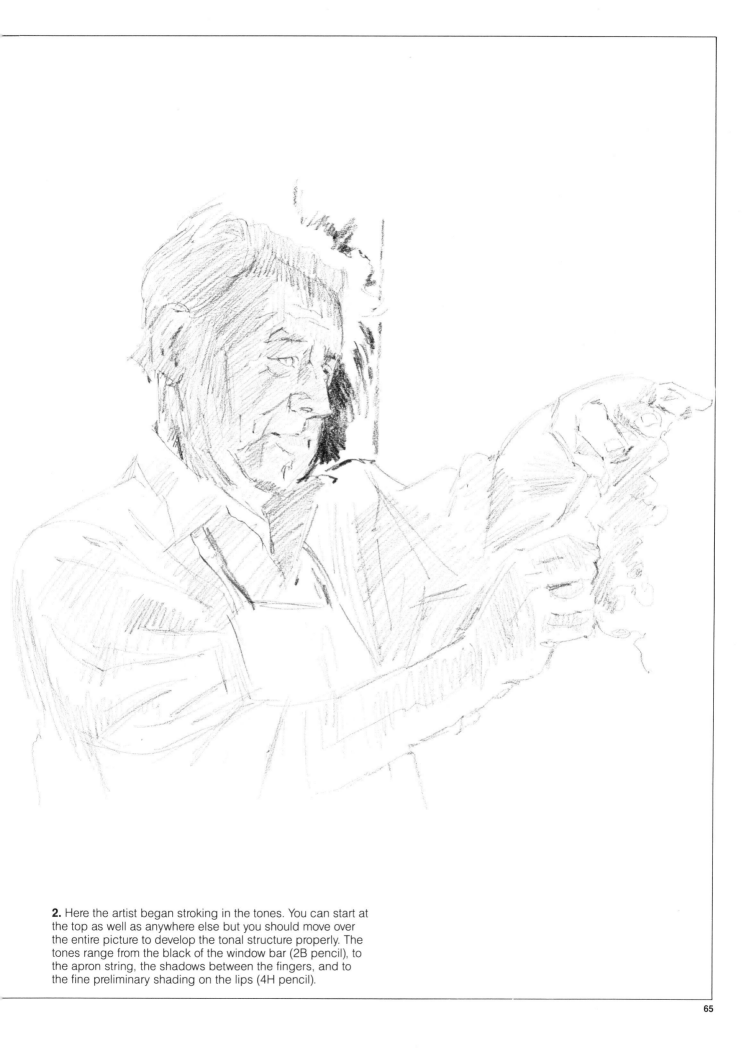

**2.** Here the artist began stroking in the tones. You can start at
the top as well as anywhere else but you should move over
the entire picture to develop the tonal structure properly. The
tones range from the black of the window bar (2B pencil), to
the apron string, the shadows between the fingers, and to
the fine preliminary shading on the lips (4H pencil).

**3.** Here the artist made the window structure heavier—by doing this he felt he'd added an emotional solidity to the picture, and he liked the silhouette created by the white hair against the window. He shaded all of the face heavier with a combination of 2B and HB pencil strokes, most of which follow a general direction, although sometimes they follow the form of the facial structures. For your own drawings, take care to shade up to and around the highlights such as those on the forehead, around the eye structure, nose, and mouth. Remember, stroking across the form can create texture.

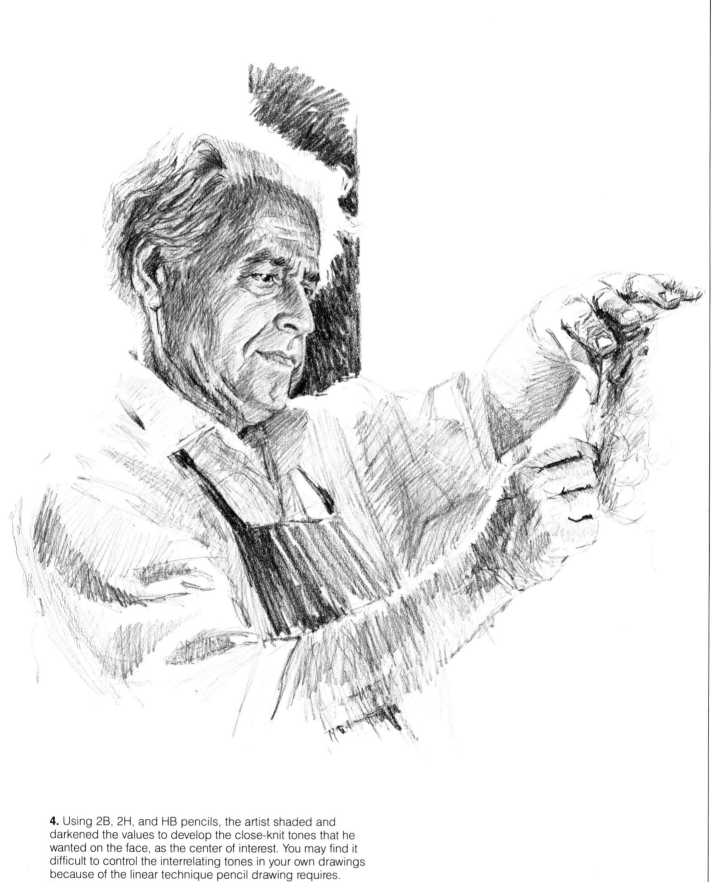

**4.** Using 2B, 2H, and HB pencils, the artist shaded and
darkened the values to develop the close-knit tones that he
wanted on the face, as the center of interest. You may find it
difficult to control the interrelating tones in your own drawings
because of the linear technique pencil drawing requires.
When drawing, you should constantly step back to get an
overall impression of your work, to see it as a whole and to
see specific fusions of the tonal planes.

# DRAWING ANIMALS

To draw an animal well, it is necessary to know and understand its personality and behavior in order to express its individual features. The purpose of this section, then, is to demonstrate, using step-by-step drawings, various types of animals—showing their similarities, differences, and unique characteristics.

The following pages include all types of animal portraits—from domestic young colts to wild tigers—resting, jumping, at play, even yawning!

# Drawing Dogs

**1.** Here is the hunting animal on the job—with tail cocked, nose alert for scents, muscles tensed for constant action. The artist began by completely drawing in the dog's outline and indicating its more important muscle, tendon, and bone structures in the torso and legs. At this stage, he was most concerned with getting the animal's shape, proportions, and attitude as correct as possible.

**2.** Here, the artist was concerned with values. Since this is a short-haired dog, the values will be closely related to the animal's muscular forms rather than to the shapes and directions of the fur. The artist placed dark tones on the inside of its hind thigh and filled in the tail to make is stand out. To accent the darkest areas of the head and body, he used choppy strokes. The rib cage is visible, due to the dog's lean, tight physique.

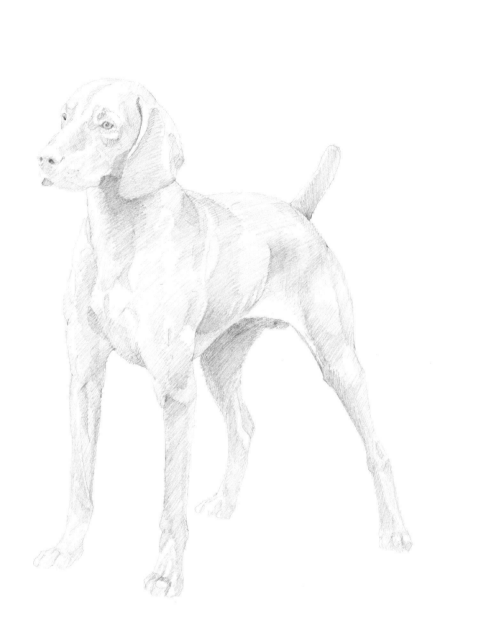

**3.** Everything is darkened, strengthened, and defined all over. The many contrasts of light and dark portray the dog's glossy short coat. A furrier breed of dog would reveal much less of the underlying anatomy. The artist used a minimum of individual strokes. Instead, he used strokes that flowed together to conform to the character of the coat. He did not draw whiskers but he did show the indentations from which they would emerge. Note the straining veins and tendons in the animal's tensed legs.

## JUMPING

This Labrador retriever is a husky, compactly built animal with a dense, bristly dark coat. In this drawing, the animal is about to retrieve game from the water, a task for which it is bred. The muscles in its neck and shoulders are bunched as a result of the jump, the ears are flying, and the tail is extended. As the dog propels itself forward, the contrasts of lights and darks in the shoulders and hips show the movement of the muscles. The front toes are splayed in anticipation of the landing.

## RESTING

Below the outstretched legs of this German shorthair, the dark tones anchor the body to the ground. The dark shadow behind the left hind stifle, or knee, brings the leg forward. Note the texture of the pad (the underside of the paw) as it faces out—it's smooth and hairless and kind of rubbery. The hair on the neck and the underbelly is rougher and bristlier than the other parts of the coat. The artist used short, dark choppy strokes to indicate it. He put the spots, or ticks, on last.

## POINTER AT POINT
This classic posture is assumed by the wellbred pointer in the field directing its master's attention to the game. Some of this breed have been known to maintain this position for over an hour. In this drawing, the dog's nervous energy and dedication to its task are evident. Because of its rather light overall coloration, the artist has kept this drawing high-key, reserving the darks for the face, tail, skin folds, and for the underlying areas of the torso and the raised leg.

## PUPPY
There is probably nothing more cuddly or lovable than a puppy, and here the artist captured successfully this youngster's soft, ungainly quality. Its head, ears, and paws are disproportionately large and they add to the pup's vulnerable air. The artist rendered the folds of the tender skin in the chest by using highlights that terminate in a short series of strokes. Note the fold formed by the position of the sprawled hind legs.

## HEAD, FRONT VIEW

This German shorthair's fur has a
rougher texture. The artist indicated
this characteristic with darker, thicker
strokes to show the animal's rather
bristly quality. Observe the happy alert
expression—the eyes are bright and
expressive, the mouth appears to be
smiling. Note how the hair tracks seem
to begin at the nose and travel up and
around the skull. The artist placed
highlights above the eyes and in the
lower eyelids, and used a razor blade
to scratch out the whiskers. Veins were
placed in the ears to promote the
feeling of authenticity.

## HEAD, SIDE VIEW

This pose is more serene and relaxed
than the preceding drawing. Dogs are
emotional and, like people, their faces
reflect their feelings. To draw animals
well, one should become familiar with
their moods. For this white dog, the
artist reserved the dark accents
basically for its eyes and nose. The
texture of the dense hair on the
ear was depicted with long,
flowing, and alternately
dark strokes of
the pencil.

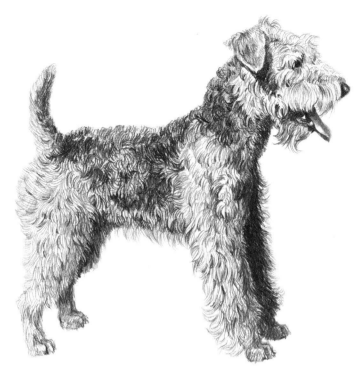

## AIREDALE TERRIER
This breed has a coat of rough, wiry hair with a softer, shorter undercoat, and a topknot of lighter, finer-textured hair. The artist bunched little groups of fur by using masses of curved pencil strokes for each, then proceeded to form other clumps adjoining these, but running, in another direction. He darkened the left front and hind legs to set them back in perspective. There is not a hard edge to be seen in any of the contours; they were all achieved with strokes pointing away from the body. In rendering a dog as shaggy as this, you need to be familiar with its anatomy.

## BULLDOG
This squat, husky fellow is noted for the courage that's been bred into it, resulting from generations of ancestors trained for the sport of bullbaiting. Today's specimens of the breed make gentle, agreeable pets. Its main physical characteristics are the squashed muzzle, the wide-set front legs, and the many folds and wrinkles of its smooth coat. It's important to know where these folds fall and to understand how they relate to the form underneath. The artist shows the glossy, loose coat with light, short strokes that run toward the rear and around the body.

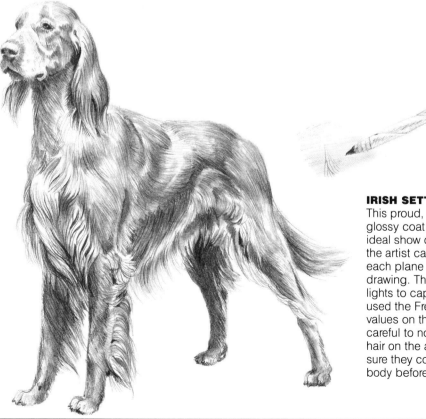

## IRISH SETTER
This proud, handsome breed features a long, glossy coat of reddish-golden hair. It is the ideal show dog. To depict its luxuriant coat, the artist carefully planned the placement of each plane of hair before beginning the drawing. The artist needed a variety of highlights to capture the sheen of the hair. He used the French stump freely to smooth the values on the form (note diagram). He was careful to note the directions of the fringed hair on the animal's legs and belly to make sure they conformed with the shapes of the body before laying the strokes.

# Drawing the Big Cats

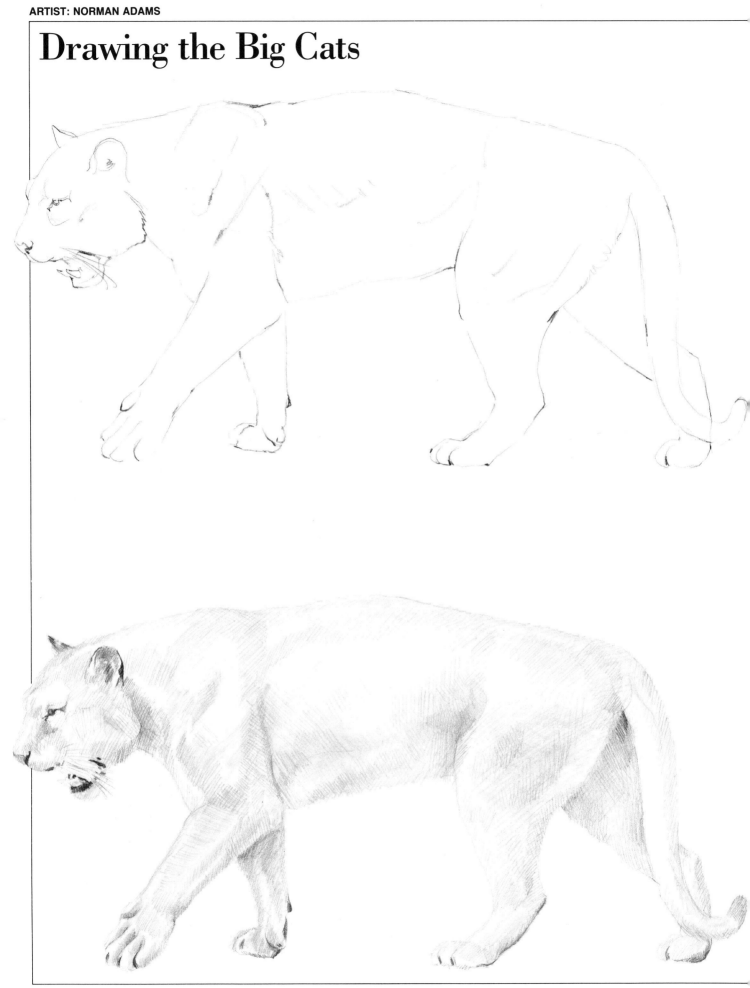

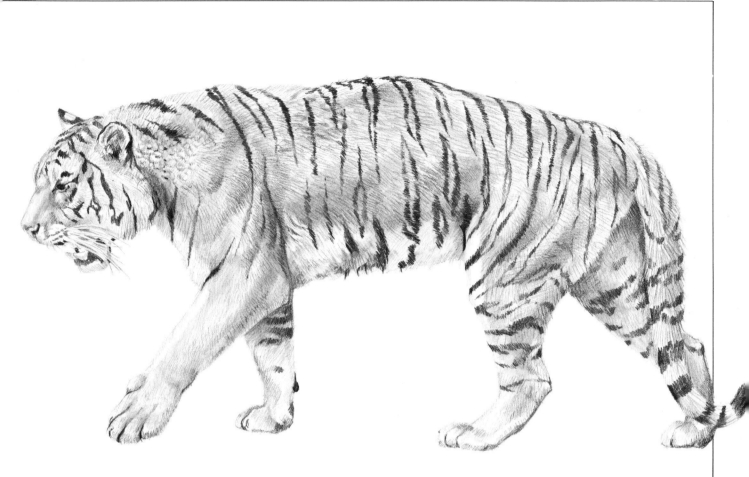

**1.** (Above left) This tiger is pacing and showing its fangs in a snarl. The artist began by drawing in the tiger's basic outline, taking care to capture the determined attitude the animal has assumed by extending its left foreleg as it moves ominously forward. He lightly noted the indentations, marking the muscular stresses this gesture has produced in the shoulder, hip, and rib cage areas. He also showed the open jaw and exposed teeth to effect the tiger's fierceness.

**2.** (Left) Here the artist indicated the texture of the fur with strokes that follow the muscle patterns. He darkened those areas that emphasize the action and attitude of the pose, such as the mouth, eyes, ears, and toes. These pencil strokes must also represent the variety of coloring on the animal—where it is orange, they are darker; where it is white, they are lighter. At this stage, the tiger resembles a female lion.

**3.** (Above) The color and tonal values and textures of fur were darkened and strengthened all over. Note the back of the ear where the artist fashioned little islands of fur to indicate their soft, bunchy quality. To get the feeling of fur, he roughed the edges of the coat. The whiskers here are negative shapes—light areas set against darker tones behind them. In areas where separate forms come together, he contrasted lights and darks. The final step was putting in the stripes; he used short, dark strokes broken up to show the fur growing beneath and between them.

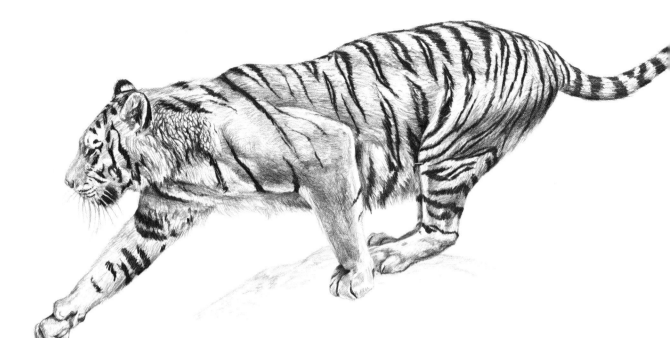

## LEAPING

This tiger is springing off a ledge. In anticipation of the landing, the right foreleg is fully extended and the toes are spread. The tail is well extended to maintain balance. The artist centered his attention on the hip and left shoulder muscles which are deeply involved in the action. Note the variety of thin pencil strokes that he used to depict the different areas of the coat.

## RESTING

In this radically foreshortened drawing, the tiger seems uncomfortably close. Its head is cocked slightly in repose. Due to the close view, the paws have a lot of detail. The artist separated the head from the torso by darkening under the chin area to make the head seem to come forward. He cut with dark stripes into the white of the ruff in the chin area, and then penciled them in lightly. Again the whiskers are negative forms. Note the distinct slant of the eyes—a characteristic feline feature, especially among the big cats.

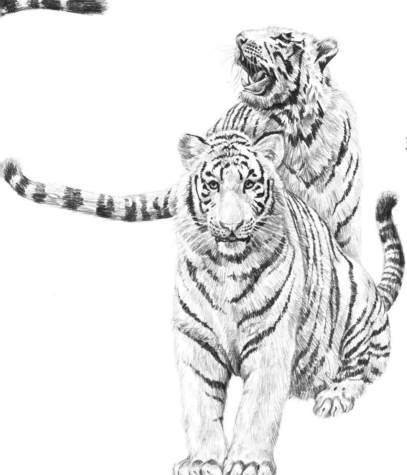

### TIGER CUBS
A tiger matures sexually between the ages of three and four. Cubs stay under their mother's protection until they are two or three, even though they are able to kill their own prey as early as seven months old. In drawing these cubs the artist attempted to portray their youthful and still somewhat ungainly appearance—for instance, note how large their legs seem in relation to the body. Because cubs' whiskers are relatively light, the artist scratched them out with a razor from a dark background (note diagram).

### PLAYING
Just like your house cat, tigers spend lots of time playing games that simulate their everyday activities. In this instance, a game of submission and domination is being acted out. The tiger assuming the aggressive role draws its ears back, fakes a snarl, and unsheathes its right foreleg claws while its playmate paws its head but with the claws well sheathed. On the head of the supine tiger, note how the stripes radiate from the center of the skull.

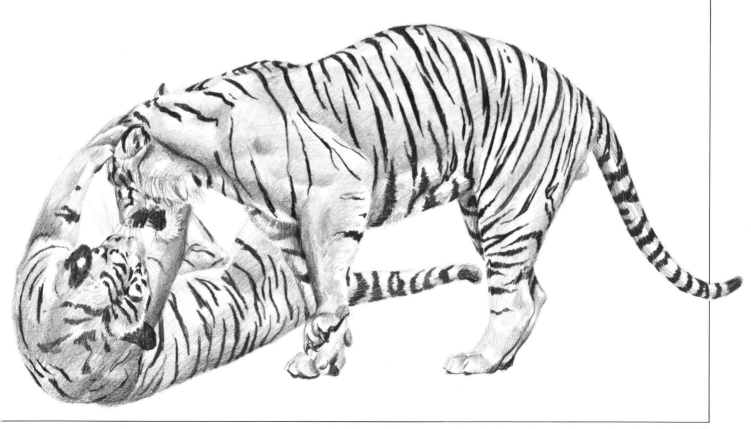

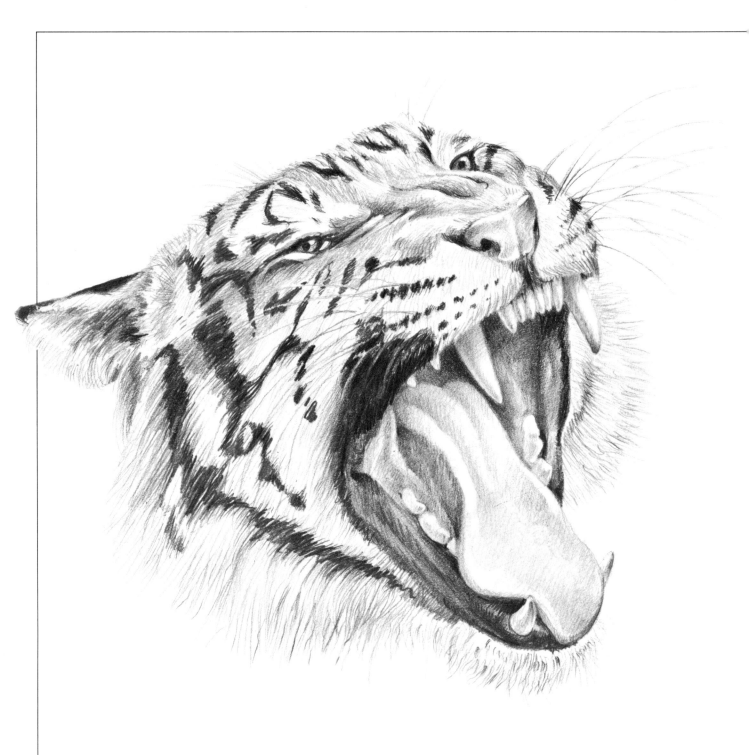

## HEAD, THREE-QUARTER VIEW

A tiger has long upper canines that have six smaller incisors set
between them. Its lower canines are set closer together and fit
between, and in front of, the upper canines when the jaw is closed. The
rims of the lips are quite dark. The wrinkles created by the yawn run
from the nose toward the eyes, which are narrowed from the wide
stretch of the jaw. Note that the eyebrows and whiskers are a texture
different from the animal's fur.

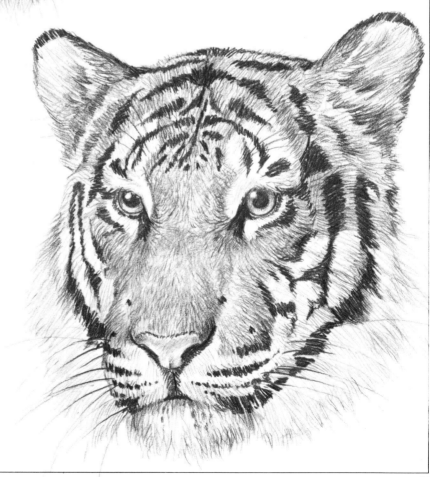

## HEAD, FRONT VIEW

Excluding the obvious stripes, the chief differences between the tiger and the mountain lion (also known as the puma, cougar, panther, catamount, etc.) are: the tiger has a longer chin ruff, longer whiskers, and a flatter nose; the puma is somewhat slighter in structure and has distinctive black markings above the eyes. It's great fun to draw the lengthy coarse whiskers of cats by pulling them out with long definite pencil strokes. Note the differences in the textures of both animals' fur—coarser here, smoother there; lighter here, darker there; straighter here, scragglier there. The pencil is the ideal tool to capture this variety.

## LION

This male's luxuriant mane represents the most striking feature of the drawing. The artist included a number of V-shaped accents in the lower part of the mane to emphasize the overlapping character of the hair, which lies in thick layers in that area. The toes are drawn somewhat unevenly to demonstrate their flexibility—cats' feet must not be drawn as solid static shapes such as shoes. You can see the slits in the toes into which the claws retract. Note the difference between the male lion's ear and that of the tiger—the lion's ear seems more human-like. The dark tuft on the tip of the tail covers a pointy, hornlike spear.

## SNOW LEOPARD

The snow leopard is a native of Asia and enjoys life at very high altitudes where it has been occasionally mistaken for the mysterious Abominable Snowman. In viewing this animal, the first thing that strikes the eye is the magnificent tail and dense furry coat. Most of this drawing entails long and flowing strokes of the pencil to capture the quality of the heavy fur, especially in the animal's underparts. The rosettes follow a rather scattered pattern and are partly diffused by the thick fur. The legs appear very stout because of their heavy burr while the head is relatively short-haired.

# Drawing Horses

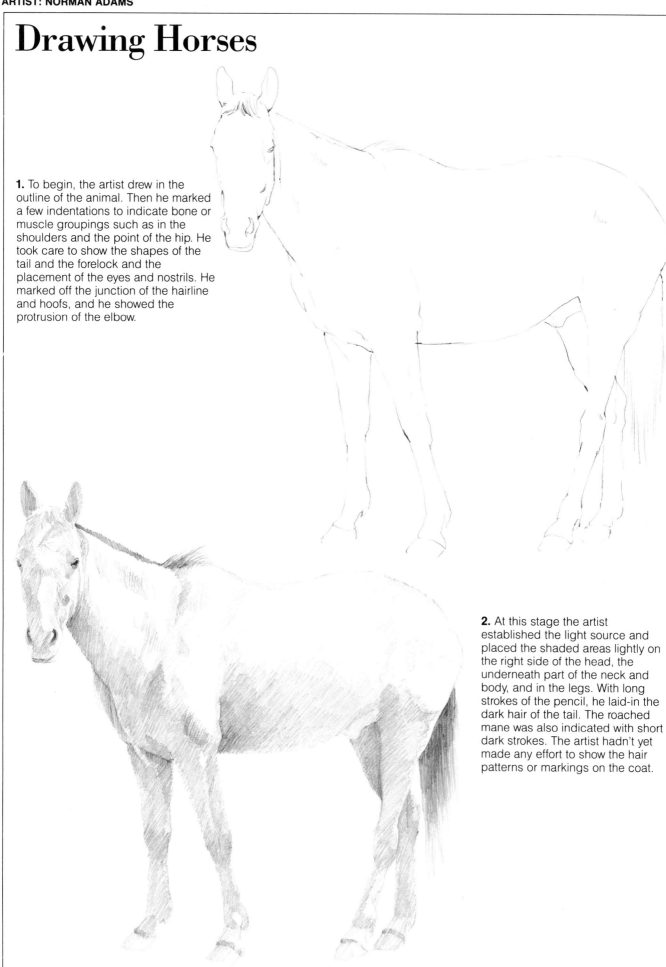

**1.** To begin, the artist drew in the outline of the animal. Then he marked a few indentations to indicate bone or muscle groupings such as in the shoulders and the point of the hip. He took care to show the shapes of the tail and the forelock and the placement of the eyes and nostrils. He marked off the junction of the hairline and hoofs, and he showed the protrusion of the elbow.

**2.** At this stage the artist established the light source and placed the shaded areas lightly on the right side of the head, the underneath part of the neck and body, and in the legs. With long strokes of the pencil, he laid-in the dark hair of the tail. The roached mane was also indicated with short dark strokes. The artist hadn't yet made any effort to show the hair patterns or markings on the coat.

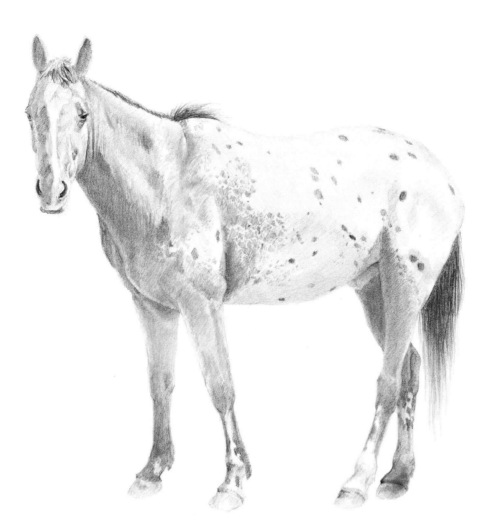

**3.** The two-tone effect of the animal's coat was achieved through contrasts of broken, spotted areas. There are dark spots over the light areas and negative light spots over a dark base such as the hind legs. The artist used the paper value as the light spot and drew the darker value around it. The white patch and streak were placed on the forehead and nose. On the animal's forelock, the hair is shown radiating from a central base. The forelock, tail, and the mane at the withers (the ridge between the shoulder bones) are the only areas where the hair is of any length; otherwise, the hair is too short to form a noticeable pattern.

## RESTING

To anchor the animals down, the artist placed lots of darks and some rocks on the ground. The artist darkened the front horse's neck against its much lighter shoulder to make it appear to come forward.

## GRAZING

In this drawing, the most important action is the long sweep of neck as this Appaloosa bends radically forward. To accent this gesture, the artist darkened the neck underneath. He outlined the animal's spots and placed a dark core inside each one before finishing them. The changes of color in the horse are shown with contrasts of light and dark that have no real sharp edges to separate them.

## JUMPING

Jumping is a highly ritualized affair in which the conduct and attire of riders and horses are closely judged. In this drawing, the rider and horse are equipped with English tack. Note the mount's braided mane and tail which are de rigueur for such a formal and important occasion as a horse show.

## YOUNG HORSE

This youngster seems all legs as it friskily swings its tail and kicks out with the rear left leg. At this age, the ribcage and muscle structure are quite evident. A young horse projects the general feeling of an awkward, ungainly creature about to topple. Grace, suppleness, and harnessed power will emerge within a matter of months.

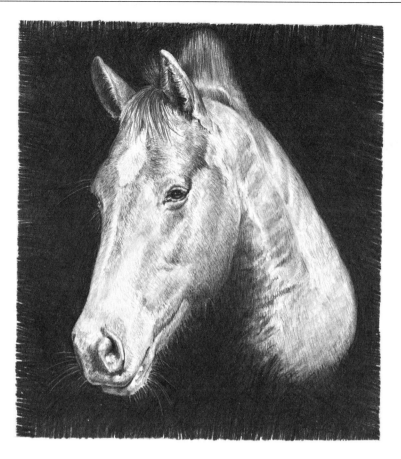

## HEAD, THREE-QUARTER VIEW

To produce this striking silhouette the artist drew the outline of this Appaloosa's head first, then filled it in with the black background. To render the mane, he drew long dark strokes into the lighter underlying area. The hair patterns on the bottom of the neck produce small islands of light and dark. He used a razor to pull out the whiskers from the muzzle and lower chin, and the right eyebrows out of the dark background. Darks were used to mark the cavities formed by the nostrils, mouth, ears, and eyes.

## BURRO

Of the donkey species, this burro is particularly shaggy. The artist exploited this shagginess making it the chief feature of the drawing. The animal's form is somewhat lost under all that hair growth so the accent is on the direction of the hair patterns. Note how the patterns run down the side of the body, up at the mane, and haphazardly on the legs. The burro's hoofs are blunt and square-shaped. His ears are long and prominent. You must use bold, definite strokes to successfully draw such an animal, or your drawing will look confused.

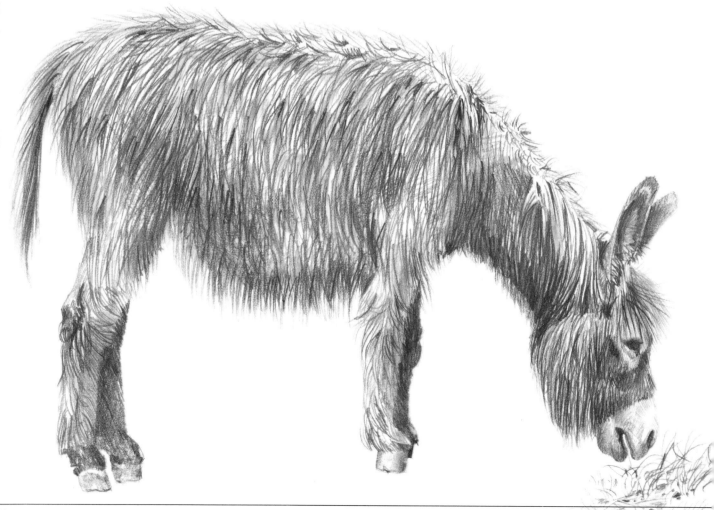

## ZEBRA

There are three kinds of zebra: Grevy's, Mountain, and Burchell's. This is a Grant's (bold contrasting stripes), which is a variety of the Burchell's or Plains Zebra. The artist began by establishing the animal's muscle structure. He then carefully drew in the outlines of the stripes. The stripes serve as camouflage and vary according to the type of zebra. In your drawings, remember not to lose the animal's muscular structure underneath. The artist completed the drawing by filling in the stripes and drawing the tail, hoofs, facial features, and mane.

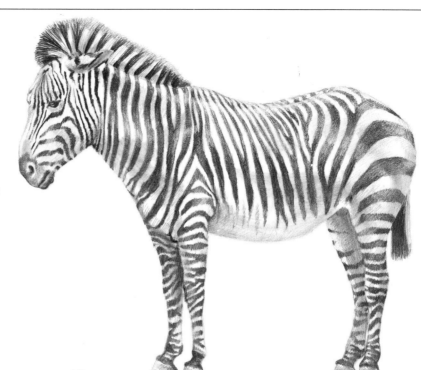

## CLYDESDALE

This breed of heavy draft horse originated in Scotland in the 18th century. Some stand as high as 18 hands and can weigh up to a ton. It is densely haired on the back of its legs and heavily boned and muscled. Since its coat is not as short or glossy as a saddle horse's, the artist represented it in a series of varied hair patterns often running crosswise. He used a kneaded eraser to pick out selected highlights on the flanks and sides of the horse. The contours of the animal's legs and torso were feathered to indicate its somewhat shaggy coat.

## PRZEWALSKI'S HORSE

This breed of wild horses is extremely rare. It has a sturdy physique, stands 12 hands high, with a short and bristly mane, a long black tail, and legs that are black from the knees down. The artist used a template (see diagram) to draw the mane. Setting its edge at the animal's neck, he pulled the strokes away from the neck to achieve the dark, straight lines he wanted. He used an HB pencil for the shadow areas, bearing down on the pencil for the darkest darks.

# Drawing a Cottontail Rabbit

**1.** The artist drew the outline of a rabbit squatting in a very alert position so it can feed without being disturbed. Note that all lines pertaining to the animal's proportions and actions are included. The eye is somewhat more finished off than the rest of the features. To indicate folds and breaks in form, the artist used dark strokes.

**2.** With short brisk strokes, the artist shaded in all the fur making sure to follow the patterns of the forms and muscles. There are no hard edges anywhere since the rabbit's coat is soft and puffy. He included some darker accents in the eyes, chin, tips of the ears, and below the pouch under the chin. Light areas were left at the junctures of the limbs to the torso.

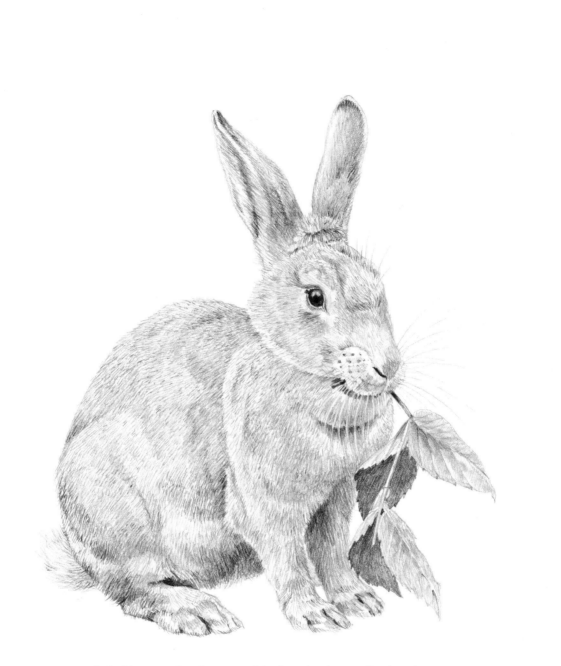

**3.** At this stage the character of the lines has been refined to shorter, lighter strokes. This kind of handling provided the salt-and-pepper effect the artist wanted. He drew the whiskers that come *away* from the rabbit by stroking out from the muzzle, while those seen against the body are shown as negative shapes. He left the eyelids blank and placed a strong catchlight in the dark, luminous pupil. Light, irregular strokes were used to indicate the fluffy, cottony tail. Note how the hair changes direction in the rabbit's topknot.

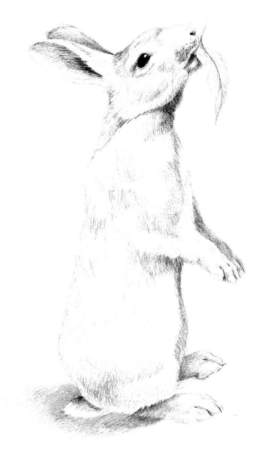

### FEEDING

The rabbit is quite capable of sitting up on its hind legs. In this pose, it probably reminds you of a squirrel. Note the difference in size between the front and hind paws. The artist's strokes on the torso are in a vertical, downward direction, furthering the impression of the sitting gesture. The cast shadow beneath the animal helps anchor it firmly to the ground.

### RUNNING

The rabbit spends much of its time running and fleeing. Note how this action flattens the ears. The artist separated the toes on the front right leg as they prepare to hit the ground, and strongly outlined the hind legs. Because rabbits are usually seen in a squatting postion, these rear legs are seldom revealed, being concealed by the torso. Because of its plumpness and quantity of fur, the rabbit's skeletal and muscle forms are not easily discernible.

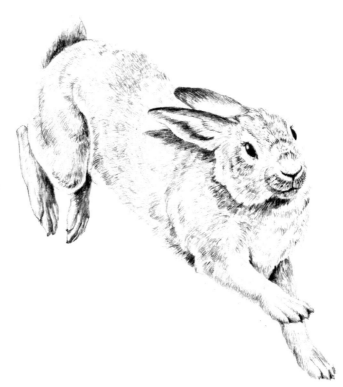

## HEAD, FRONT VIEW

The artist placed his strokes fairly far apart to show the animal's light, fluffy coat. The rabbit's whiskers and eyebrows are very pronounced so he drew them with long, unbroken lines paying careful attention to their root, or base, in the head. Note the absence of a bare, dark area on the tip of the nose as seen in most other mammals. The eyelashes are quite long. By changing the character of the strokes in various areas, the artist shows the softness of the fur.

## BABY COTTONTAIL RABBIT

The young cottontail is a very cute and appealing animal. Its eyes are the darkest accents against a downy coat that's much lighter than its parents'. To see a young cottontail nearly motionless except for its twitching nostrils is a very pleasurable experience. The artist kept his strokes light and spread apart to produce this essentially high-key drawing.

# Drawing Small Animals

**GRAY SQUIRREL**
The gray squirrel is basically arboreal. It builds nests in trees and is perfectly at ease leaping acrobatically from branch to branch. Note the sharp claws that allow the squirrel to climb and grip the thinnest branches. Squirrels come down from trees to bury nuts and other food, and to get from tree to tree when they cannot leap.

**HEAD, SIDE VIEW**
A gray squirrel's eye is all pupil and almost perfectly round. The artist lightly toned the inside of the ear to show its thin translucent tissue against the light coming from above and somewhat to the rear. He accented the tip of the nose. The squirrel, like the rabbit, has long, abundant whiskers. In this drawing, the artist depicted the animal's vulnerable, appealing quality.

**PRAIRIE DOG**
The prairie dog is a member of the rodent family and has the typically large, prominent incisors. It has a long body, short legs, large front claws for digging, and cheek pouches in which the animal transports food for storage in its underground burrow. When challenged, the prairie dog can be a formidable fighter. The artist used crisp short strokes and lots of highlights to show the animal's short, glossy fur. The folds in the skin are formed by the action the animal has taken.

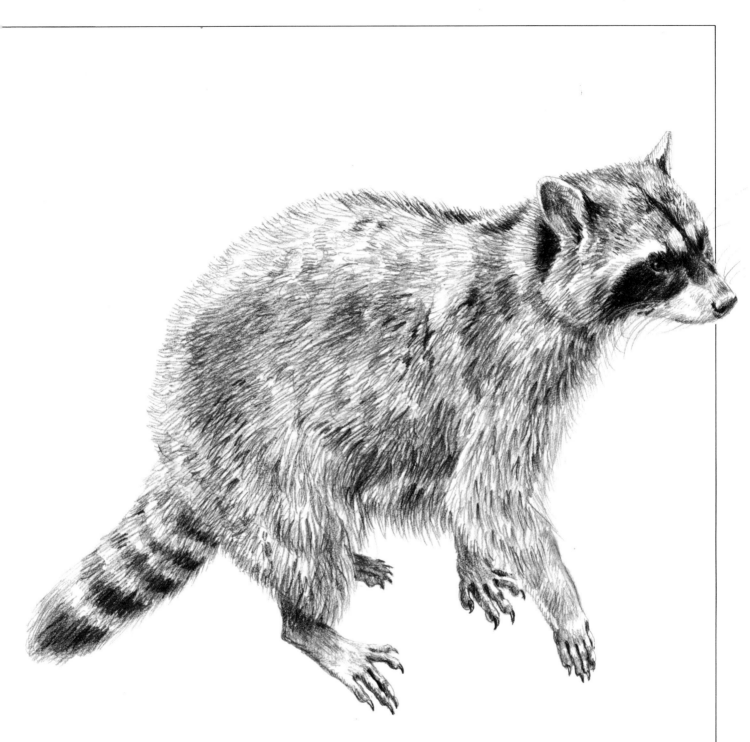

**RACCOON**
This lovable scalawag, with its black mask, ringed tail, and sly, cunning
ways, is a favorite of the artist's. Using many crisp dark and light
strokes, he rendered the animal's thick, bushy coat. The face is fox-like
with a dark streak up the forehead. The coon is nosy, daring, and
resourceful.

# DRAWING FOR WATERCOLORS

Notice that every drawing in this section contains just enough information for painting and that the arrangement of pencil or Conté lines tells the artist what to emphasize. Study each drawing with this in mind, and in your own work develop a system of noting shapes and textures, so that you resolve the plan for your painting during this preliminary stage.

Putting excitement and vigor in your watercolor paintings depends on your ability to capture in pencil the *very essence* of a subject, so that you have a clear idea of exactly what you want to paint and can work out a plan for rendering the key textures before you begin to paint.

# Planning Your Composition

The charm of drawing is that, like handwriting, everyone has his or her own different style that has developed with observation, concentration, and practice. However, with drawing, it is important not to be fixed or rigid. Varying the medium can make a difference, as can the speed at which you execute a drawing. With every drawing, spend a minute beforehand to decide whether you need a studious, highly detailed drawing or a swift set of visual notes for future reference. Sometimes Richard Bolton prefers to produce a tightly controlled, highly complex drawing. At other times, when he wants to be more expressive, he dashes down bold lines, using the side of the pencil and digging in the tip to create vivid linework. The most common drawing fault is an overtight line, which comes

from the belief that everything should be stated in total on the paper. As an exercise, practice drawing in values alone, so that you suggest edges by changing light and value, rather than with line only (the value exercise suggestions on page 12 are a good place to start). If your drawing or painting suffers from tightening-up, the best remedy is to allocate yourself only a short time to work. That way you don't have time to overwork certain passages with excessive detail, and you're forced to make quick decisions.

If you find drawing a struggle, choose a subject that does not really need accurate technical draftsmanship. Remember that it is much easier to use a modicum of drawing and then depend on your skill and dexterity with watercolor to create tex-

tures that give character to a painting. Richard Bolton feels that it is the careful application of paint that creates the illusion of precision engineering on the objects in his paintings. If you *draw* an engine, for example, rather than *paint* it, you'll produce a technically accurate rendering, but it will be stiff and lack your interpretation. In his own work, this artist feels that it's often color and texture that make a good painting, not the drawing.

But in the experience of Richard Bolton, and other artists, drawing is an integral part of the thinking process of watercolor painting. Without it, paintings sometimes lack structure and shape, and can suffer from a lack of definite composition. So take the time to draw before you paint—you will never regret it!

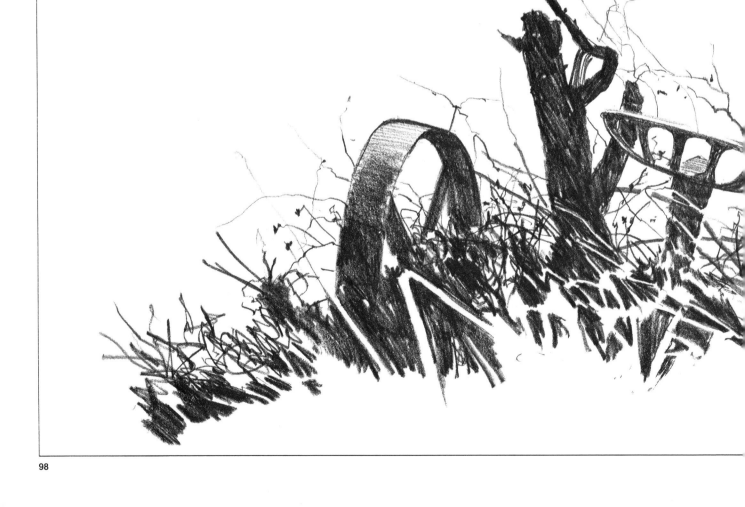

## PLANNING COMPOSITION

The artist found this old grass rake submerged in a tangle of dead grasses and weeds behind an old barn. The heavy steel wheel and seat had been there for some time, and their shapes and well-rusted surfaces seemed to be a great potential painting subject.

He made the drawing with Conté pencil and used very few mid-gray values. He relied on a stark contrast of black and white to emphasize the smooth, round, symmetrical man-made shapes against the ragged, random natural forms.

He juggled the composition of the shapes and left out many foreground details to make the preliminary design for a future painting. He toyed with the negative shapes of the foliage in the foreground, and looked for a pattern of values that would offset the manmade seat and wheel above.

Since the artist half-buried the rake in the long grass, this drawing demanded only a little technical drafting skill. It is quite easy to render seemingly awkward shapes in this way, without having to be highly proficient at technical drawing.

# Establishing Values

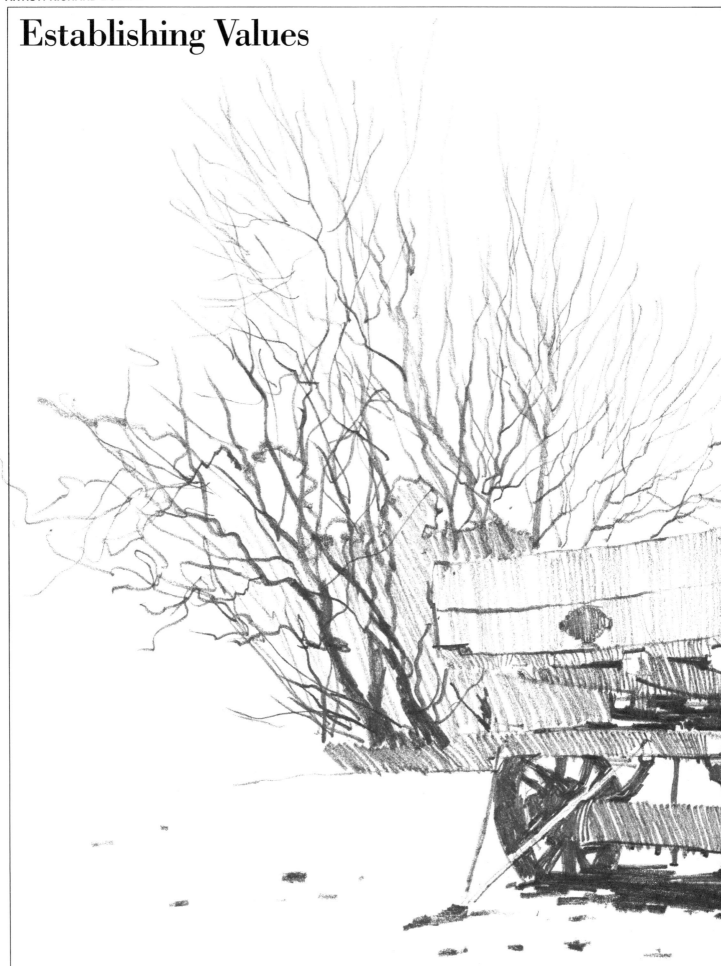

Rather than become buried in the mass of technical details under the chassis of this old cart, the artist started this drawing by lightly marking in the basic features of the chassis and then adding those of less visual appeal with hatched-in values. Notice that the axles and cross members on the cart give the impression of being complicated in structure, but they are only loosely stated. The artist just suggested the shadows between the spokes on the wheel in the foreground, yet it has weight and that certain chunkiness, too. Notice how the artist arranged the tree branches to form a satisfactory V-shaped composition with the cart and outbuildings.

# Recording Character in Detail

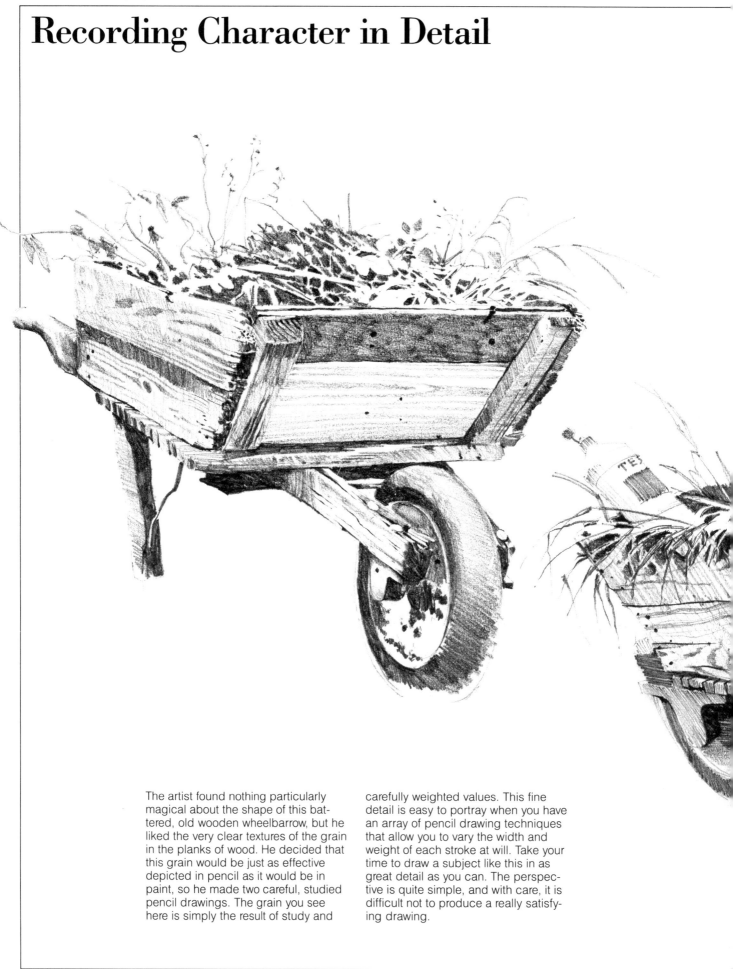

The artist found nothing particularly magical about the shape of this battered, old wooden wheelbarrow, but he liked the very clear textures of the grain in the planks of wood. He decided that this grain would be just as effective depicted in pencil as it would be in paint, so he made two careful, studied pencil drawings. The grain you see here is simply the result of study and carefully weighted values. This fine detail is easy to portray when you have an array of pencil drawing techniques that allow you to vary the width and weight of each stroke at will. Take your time to draw a subject like this in as great detail as you can. The perspective is quite simple, and with care, it is difficult not to produce a really satisfying drawing.

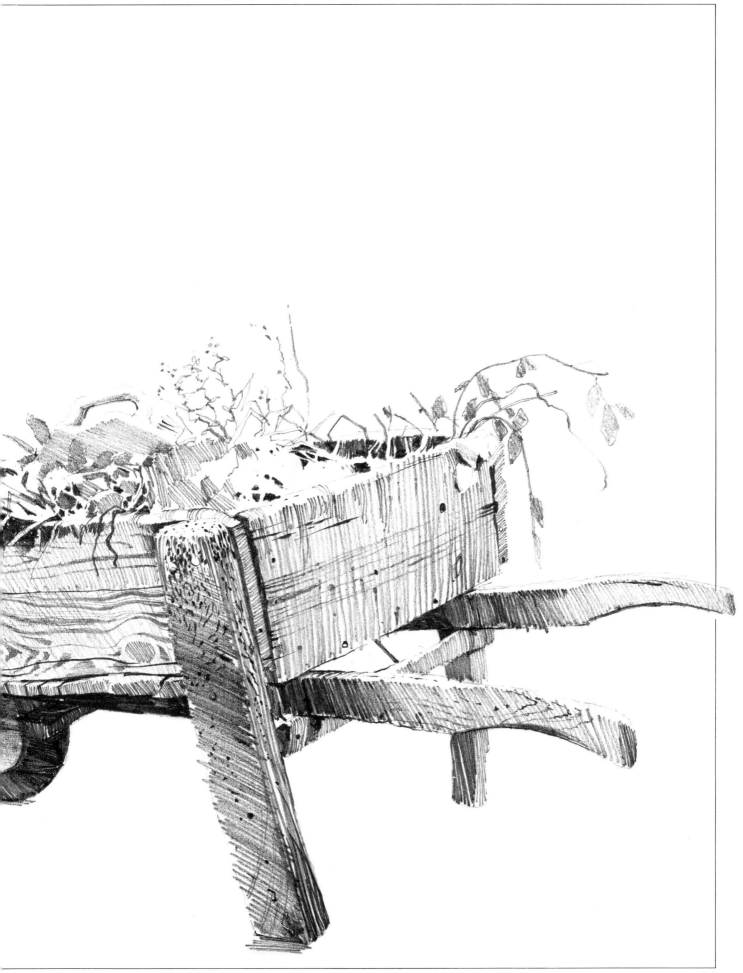

# Evaluating Shapes

The key to this drawing, for Richard Bolton, was the shapes of the windows. The car was beaten and bent, so the artist could have arranged them to suit himself, but he chose not to. He concentrated on nothing but the outline drawing of the car and once that was right, he began to establish some values to give the correct planes to all the pieces of metal. The windows in this drawing are an example of when it is necessary to draw very precisely around objects rather than roughly suggesting them. Where the weeds covered the car, the artist left some areas undrawn: so long as the focal point of the drawing—the windows—was established, everything else was less important and needed less detail.

# Drawing Areas of Interest

The artist thought it would be more interesting to show this grindstone from the underside rather than from a more conventional vantage point, so he crouched down in the grass to draw it. As he drew, he carefully studied the construction of the various parts. He was particularly intrigued by the farmer's ingenious improvisations—supporting the grindstone on two steel bars pushed into a stone wall; resting in the front on a stone slab. The artist used a sharp pencil to suggest the taut curves of the forged handle and a stick of graphite for the heavier tones and lines. To magnify the effect of the strong perspective, he increased the pencil pressure where the object was nearer.

GRIND-STONE
CUMBERLAND
FARM.

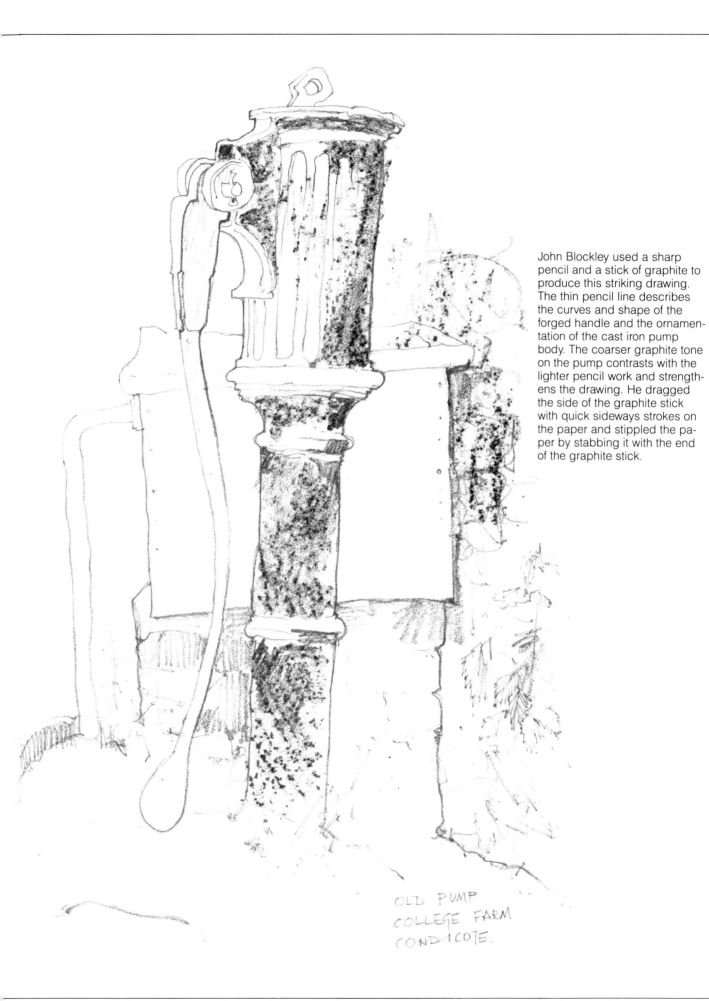

John Blockley used a sharp pencil and a stick of graphite to produce this striking drawing. The thin pencil line describes the curves and shape of the forged handle and the ornamentation of the cast iron pump body. The coarser graphite tone on the pump contrasts with the lighter pencil work and strengthens the drawing. He dragged the side of the graphite stick with quick sideways strokes on the paper and stippled the paper by stabbing it with the end of the graphite stick.

OLD PUMP
COLLEGE FARM
CONDICOTE.

# HANDLING COLORED PENCILS

Color mixing is exciting in any medium, but there is a special thrill handling color with colored pencils. The colors they yield are so instantly available—with no setting up of cumbersome paraphernalia—and they can be rapidly mixed and changed on the paper. Colored pencils also excel in tonal drawing. This exciting section on handling the colored pencil covers color mixing, tonal techniques, burnishing your colored pencil artwork, and using colored pencils with a solvent.

# Using the Colored Pencil

A major difference between colored and graphite pencils is that the colored pencils are semiopaque, a quality that can loosely be called "transparent." In some ways, this characteristic makes handling colored pencils similar to handling watercolor, which is also based on a transparent system of pigmentation. Because of the transparent quality of colored pencils, the hue of one pencil applied over another will combine visually to create a new hue.

An example of this transparent quality can be seen when the hue of a yellow pencil overlaid on that of a blue becomes a green. Artists who regularly work in this medium handle colored pencils in this way, layering from two to as many as ten separate hues for composite results. Such complex color constructions are pleasing and involving to look at and can—sometimes with astonishing accuracy—resemble the mingling of color in nature itself.

Color right out of the tube—in the context of oil painting—is said to be raw and to lack subtlety. Similarly, this is true of colored pencils; unmixed hues almost always convey a simplistic rawness when compared with layered or constructed hues. The handling of colored pencil's transparency, which is its greatest difference from graphite, cannot be ignored if any effectiveness or breadth in this medium are to be realized.

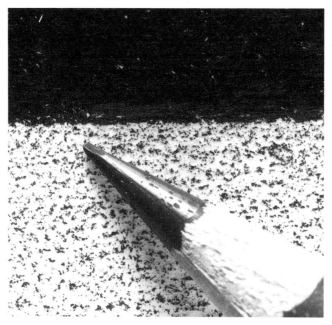

The effects of pencil pressure on a paper's surface can be seen in this close-up view. The dark area at top is dense pigment material deposited on the paper with heavy pressure. Few visible flecks of white remain of the paper's valleys. The granular area at bottom represents the same dark pigment material—applied with light pressure—deposited only on the paper's hills.

## COLORED PENCILS CONTAIN COLOR

As obvious as the above statement may seem, there is a compelling reason for stressing it. Because when color is inherent in any medium, the considerations of its application techniques begin to arise. Is the color applied thickly or in thin glazes? Is it to appear dense or sparse? In painting, the application of color is manifested as brushwork and the support surface. With colored pencil, the control of color application is handled with pencil pressure and paper texture.

Depending on the techniques used, colored pencil work can reflect the character of a drawing or it can look more like painting, and it can resemble either one without the use of solvent. In yet another difference from graphite—in which pencil pressure is varied to modify the width and value of line—degrees of pressure are used in colored pencil work to modify the texture of the paper itself. Colored pencil pressure also influences the intensity of hue: light pressure yields a sparseness of color; heavy pressure produces color density.

Pencil pressure is related to the degree of "tooth" on a paper's surface. Paper is composed of interwoven fibers that up close resemble a tiny maze of "hills" and "valleys." When a colored pencil travel lightly across a paper surface, the pigment material becomes deposited only with the hills. Flecks of unpigmented paper in the lower valley areas appear as an overall granular texture; this is the look associated with much of drawing.

By contrast, when colored pencil is applied to the same paper surface with heavier pressure, the pigment begins not only to build up on the hills, but is also pushed down into the paper's valleys. As flecks of clear paper in these valleys become less visible, the work takes on a less granular look. The fluid look of densely massed color closely resembles the look of color in painting.

## COLORED PENCILS ARE FORGIVING

One of the extra benefits of working with colored pencils is that, like oil paints, they are forgiving in use. Whatever techniques of line or tone are attempted, there is plenty of room for error and recovery. As in painting, a color can be laid down, then adjusted and readjusted as a sought-after value or hue is gradually developed. It is not a "do-or-die" medium.

## A NOTE ON "WAX BLOOM"

When heavy pressure techniques are used or when many layers of colored pencil are superimposed, a condition called "wax bloom" sometimes occurs within a week or two that looks like fogging or fading. This is caused by an exuding or excess wax on the paper's surface. And although it is not a serious condition, it may seem startling when seen for the first time.

Fortunately, wax bloom is easily corrected or avoided altogether. On a completed drawing, wax bloom can be removed from affected areas by lightly rubbing the surface with a soft cloth. Because colored pencils do not smudge easily, this rubbing should not disturb the drawing. As a follow-up, one or two light coats of fixative can then be applied, if you are sure that it will not alter the color.

To prevent wax bloom from occurring in the first place, a drawing can be sprayed immediately following its completion with a good quality fixative.

The effects of pencil pressure on a paper's surface can be seen in this close-up view. The dark area at top is dense pigment material deposited on the paper with heavy pressure. Few visible flecks of white remain of the paper's valleys. The granular area at bottom represents the same dark pigment material—applied with light pressure—deposited only on the paper's hills.

# Selecting Colored Pencils

Personal experience is the best guide to finding the brands of colored pencils most useful to you. Here are some of the pencils now available, with a few brief remarks about them:

**A.** Berol Prismacolor (USA)—Excellent, smooth "lay-down"; superior hue saturation; and soft, thick leads.

**B.** Venus Spectracolor (USA)—Close runner-up to **A**.

**C.** Derwent Studio (Great Britain)—Adequate lay down; hue saturation less strong than **A** and **B**; medium-soft, thick lead.

**D.** Niji (Japan)—Similar in quality to **C** but fashioned as mechanical pencil with separate leads.

**E.** Caran D'Ache Supracolor II (Switzerland)—Similar to **C**; water solubility is an additional feature.

**F.** Venus Watercoloring (USA)—Hard, thin lead; weak hue saturation when used dry, but excellent when used with water; offered in limited hues only.

**G.** Berol Verithin (USA)—Similar to **F**, but not designed for use with water.

**H.** Mongol (USA)—Similar to **F** but has even weaker hue saturation when used dry; excellent when used with water.

**I.** Stabilotone (Germany)—Designed for use tonally with water but can also be blended by rubbing.

**J.** Carb-Othello (Germany)—Included here as a reference. This pencil is actually a pastel rather than a true colored pencil; contains much less binder, therefore handling differs greatly. Blends easily by rubbing, unlike colored pencils.

**K.** Conté (France)—Similar to **J**. In order to standardize hue designations in this text, all numbers and names will be those of the Prismacolor pencils made by Berol. The following assortment of pencils will furnish you with a more than adequate start at representing the colors of the spectrum and will serve as a basis for mixing many additional hues:

**Blues:**
901 indigo blue
903 true blue
933 blue violet

**Greens:**
907 peacock green
909 grass green
910 true green
911 olive green
912 apple green
913 green bice

**Yellows, Reds, Violets:**
914 cream
915 lemon yellow
916 canary yellow
917 yellow orange
918 orange
921 vermilion red
922 scarlet red
923 scarlet lake
924 crimson red
929 pink
931 purple
932 violet
956 light violet

**Earths:**
937 Tuscan red
942 yellow ochre
943 burnt ochre
947 burnt umber
948 sepia

**Neutrals:**
935 black
938 white
949 silver
962 warm gray, medium
964 warm gray, very light
967 cold gray, light
968 cold gray, very light

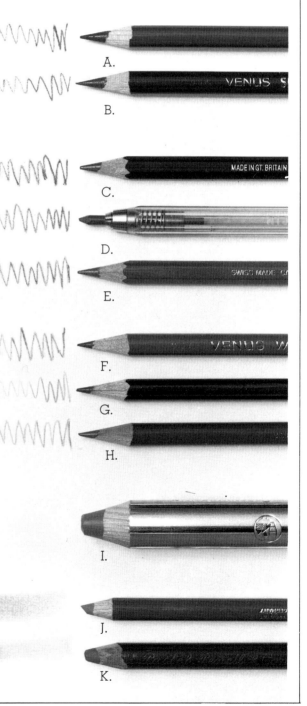

# Mixing Colors

Mixing color with colored pencils is a quick, almost instant procedure that requires very little equipment. Artists who work with these pencils often report experiencing an intensity of concentration—a total absorption—which takes them by surprise. The medium's speed and directness of handling usually spurs these colorists on to further experimentation, which is excellent, since an active pursuit of color often brings fresh and unfamiliar results.

This is a good time to think about starting a personal workbook for your colored pencil drawings, if you don't have one already. This book should be separate from your regular pencil workbook. The most useful kind for your colored pencil drawings is one with pages of a medium-grained surface very similar to that of your everyday drawing paper. For example, the Strathmore 400 Series drawing paper is inexpensive and comes in a 5½" × 8½" notebook, and also in small spiral-bound tablets. Either version would make a good workbook.

## THE DIMENSIONS OF COLOR

Color mixing involves the three dimensions of every color: hue, value, and intensity. The varying, or mixing, of a color is actually a varying of one or more of these dimensions. The meanings of the three dimensions of color are discussed below.

**Hue.** A color's *hue* is its name: red, yellow, blue-green, etc. It also denotes a color's place on the spectrum. Hues are said to have "temperature"—those approaching red are warm and aggressive, those nearer blue are cool and reticent. To visualize other relationships among hues—to show which are complementary (opposite), for example, and which are adjacent (neighboring)—colors are often arranged in their spectrum order on a color wheel. Black, white, and the various grays are not considered hues, but neutrals.

**Value.** The lightness and darkness of a hue is its *value*, as if on a scale from white to black. Gradations of value are critical when describing form in art, building a composition, and evoking mood.

Scales of value, often presented in chart form, can contain anywhere from a few to several distinct gradations. You can assess values easily with grays or with a single hue. Determining value gradations becomes more difficult when several different hues are involved as a group, but this becomes easier with practice.

**Intensity** (also called *chroma*). This describes the purity of a color in terms of its brightness or dullness. A hue of strong or high *intensity* appears vivid and saturated. It also has a simple and straightforward quality and is usually unmixed. A hue of weak or low intensity appears dull and unaggressive. Remember that, in a color sense, "dull" is not a pejorative—it is merely the opposite of "bright."

## ALTERING COLOR'S DIMENSIONS

Color mixing is done by deliberately altering one or more of color's three dimensions. You can manage these color alterations in a variety of ways—many of them unique to the colored pencil medium.

The *hue* of a color is changed by mixing another hue with it. You can do this in two basic ways:

1. *Combine two or more pencil hues by superimposing or layering one color on top of another.* You might use this method to express the rapid hue changes of a sky at sunset.

2. *Combine two or more pencil hues by placing them side by side.* The energetic hue changes in a blooming garden might be shown in this way.

The *value* of one color is changed by adding another color or a neutral that is lighter or darker to the first color. There are three basic methods for accomplishing this with colored pencils:

1. *Change the pencil pressure.* When you look at a colored pencil lead, you see that pencil's color at its darkest value. By changing pencil pressure, you are in effect combining more or less of the paper's whiteness with the pencil's color. Moderate to heavy pressure will transfer a deeper value to the paper; lighter values will be expressed by lightening the pencil pressure. This method is useful for gradating values on a flower petal without changing the petal's original brilliance or hue.

2. *Overlay a color with a white or black pencil.* A white pencil overlayed on a dark color will raise or lighten that color's value, but overlaying has little effect on colors that are already of a medium to light value. White pencil excels as an overlay when rendering the effects of glazed surfaces, such as those found on porcelain or stoneware.

Overlaying black pencil on a color of any value will lower or darken that color's value. Because black also deadens hue and affects the intensity of a color, overlaying with black pigment must be done very carefully. For a city street at dusk, where hue and intensity are intended to be dimly expressed, overlaying with black can be an excellent method of changing value. But used too much or inappropriately, black-altered values can produce a sameness that is tiresome.

3. *Overlay a pencil's color with a lighter or darker color.* Although this method also changes a color's original hue and intensity, it is the colored pencil medium's liveliest way of changing values. The new values arrived at seem crisp and decisive and filled with a richness of hue. This method works well for a portrait's pattern of light and dark values, accompanied as they are by subtle hue changes.

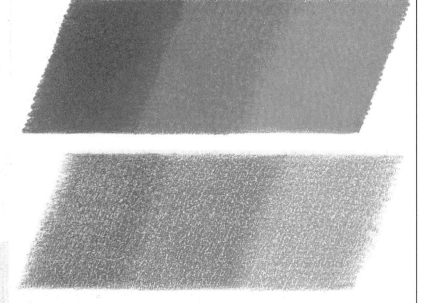

Color can be bright in intensity (top) or dull in intensity (bottom). "Dull" is not a pejorative in terms of color but is merely opposed to "bright" and can often serve as a useful variation.

As you see from this pair of charts, the values of a single color (left) are easy to assess and arrange in a progressive order of darkness to lightness. It becomes more difficult to assemble a similar scale of values when colors of differing hues and intensities are used (right).

Colored pencil offers two basic methods of altering a color's hue: by tonally overlaying or superimposing separate hues to construct a new hue (top); and by the juxtaposition of separate hues (in this example with a linear technique) for the visual illusion of a new hue (bottom).

# Changing Value

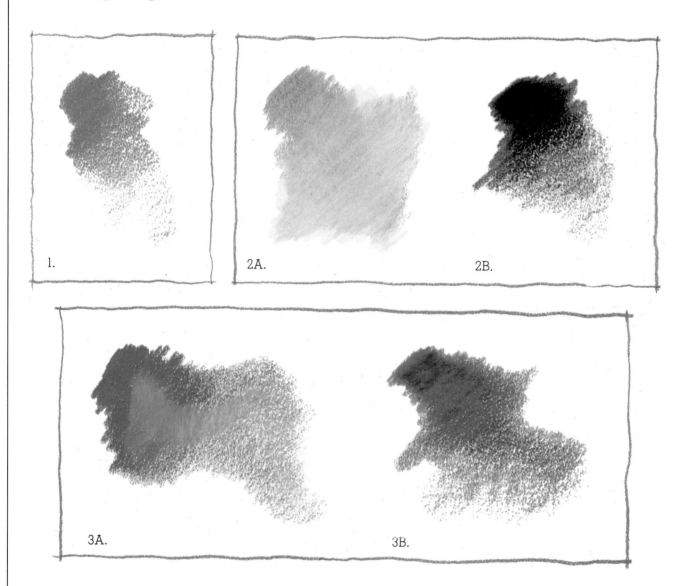

1.

2A.   2B.

3A.   3B.

There are three basic ways of changing the value of a colored pencil's color:

1. Changes in pencil pressure. As more or less whiteness of paper is allowed to show through, the value of a color will appear darker or lighter.

2A. Overlaying a medium-to-dark color with a white pencil. This lightens value.

2B. Overlaying any color with black will darken its value.

3A & B. Overlaying a color with another color, lighter or darker than itself. This method also causes changes in hue and intensity.

# Changing Intensity

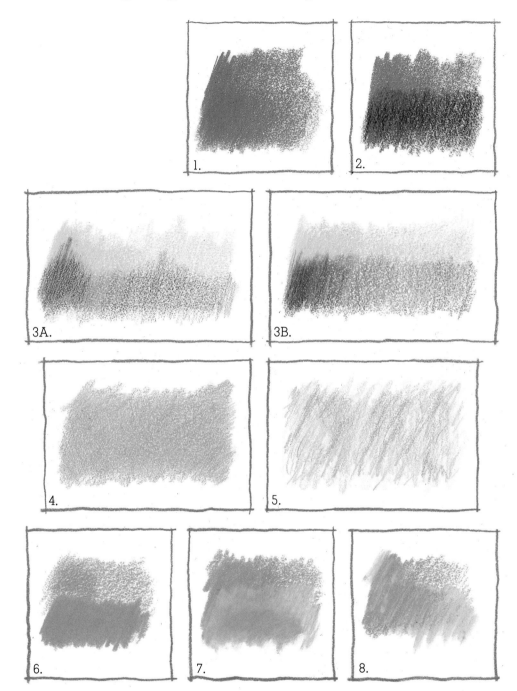

A colored pencil's color can be lowered or raised in intensity by various methods.

Intensity is decreased by:

1. Overlaying with a neutral gray.
2. Overlaying a color with black.
3A. Overlaying a color with that of a complementary hue. Using a second color exactly complementary to the original should yield little or no hue change.

3B. Using a near-complementary over the original hue.

4. Thoroughly combining a pencil's color with the two colors adjoining it on the color spectrum. This method tends to subdue intensity more than actually reduce it. In this example, 917 yellow orange was subdued by mixing 918 orange and 916 canary yellow with it.

Intensity is increased by:

5. Loosely combining a color with the two colors adjoining it on the spectrum. This is more an optical than a physical effect, related to how we perceive juxtaposed colors. This time, the 917 yellow orange was made more intense with the same 918 orange and 916 canary yellow that was previously used to reduce its intensity.

6. Increasing pencil pressure. Raising intensity in this way also greatly darkens a color's value.

7. Overlaying a color with white pencil, then adding more original color to this mixture.

8. Combining a pencil's color with solvent. The result visually resembles that of heavy pencil pressure. However, using a solvent can also intensify color of light value without darkening it.

# Developing a Discerning Eye

A good eye for color is worth striving for. Sometimes this ability seems intuitive, but in more cases than not, it has been patiently learned. Two areas of skill are involved in developing a good eye for color. One is an ability to recognize and describe a color, whatever its surroundings, in terms of its three dimensions. With this ability, you can make rapid judgments about an existing color mixture's relevance or usefulness. The second area of skill, which grows out of the first, is an equally sure knowledge of how to alter color appropriately by making changes in its dimensions.

A color's temperature is also a factor in how you see color. Warm colors appear warmer and cool colors appear cooler when they are seen against their opposites in temperature. Color temperature also plays a strong part in color's seeming ability to advance or recede in space; warm colors often appear to come forward, and cool colors appear to retreat. A color of more brilliant intensity or of lighter value than its neighbors also seems to come forward in space.

Color also has a profound effect on our emotions and on how we perceive spatially. To better understand how this pertains to drawing with colored pencils, consider what color can offer a drawing's mood and structure:

### MOOD

While most people don't completely understand how sensations of color affect the emotions, it is pretty apparent that they do. People are drawn to color, and they react to it. Memories and associations with certain colors of life bear this out. Most people have special feelings for particular hues.

For many, warm hues suggest activity and vitality. Red, among these hues, may seem particularly compelling. But in great quantity, this same red may bring a shift in mood from vitality to something nearer paralysis. Moods can also be swayed by a color's value or intensity. Light values may seem cheery and open, dark values gloomy. High intensity of color may seem to promote excitement, but low intensity brings a feeling of calm.

A good beginning toward evoking mood in your drawings can be made by observing the colors in your life. Try asking yourself, in environments that set a mood, what part color plays in the setting. Look for the dominant color, and define it by its value and intensity as well as its hue. Look for contrasts among these things. Note how the location and amount of color can affect mood.

As a practical experiment, make a few small thumbnail drawings with your colored pencils. Use as few drawn clues as possible to suggest mood, except those of color—its placement and its quantity.

### STRUCTURE

Color also can work its effects on a drawing's structure, which refers to all the elements in a drawing that contribute to the illusions of form and space. You will find as you work with colored pencils that color alone can build some of structure's illusions. It was, incidentally, to work with this premise that the colorist Paul Cézanne devoted much of his painting life.

The capacities of color alone to achieve effects of distance, perspective, solidity, and changes in plane, hinge largely on its ability to visually advance or recede. In practical terms, this "action" of color can be utilized when a shape—a table, for instance, or an object on the table—needs to be brought forward or pushed deeper into a picture's space.

A color's hue—aside from its relative warmth or coolness—can also be used to enhance the modeling of form. Because colors under different degrees of light appear to shift toward adjacent hues, an increase in illumination makes blue, for example, become more blue-green. Red, under this condition, becomes nearer red-orange. With decreasing illumination, blue becomes more blue-violet, and red more red-violet.

Finally, perhaps the single most important thing to know—for gaining adeptness at mixing colors as well as for sharpening an eye for color—is that all colors have equal status in art. None is by definition useless or ugly. Each, given proper circumstances, can be beautiful and hard-working. What you're really looking for, when you mix color, is appropriateness. The great advantage of colored pencils, as a medium for learning about as well as for drawing with color, is the speed and ease with which you can put color ideas to practical tests.

A

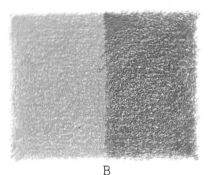

B

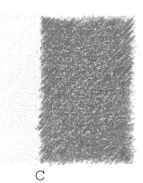

C

**A truism of color perception that is not always true is that warm colors invariably advance and cool colors recede. With no other visual clues than the colors themselves, the second two of these three combinations can be seen to advance or recede for different reasons. In A, the warm orange appears to come forward from the cooler blue at its side. But in B, the cool blue also comes forward because it is brighter in intensity than the warm but dulled red. And in C, a light value of blue seems to advance from a darker value of the same hue.**

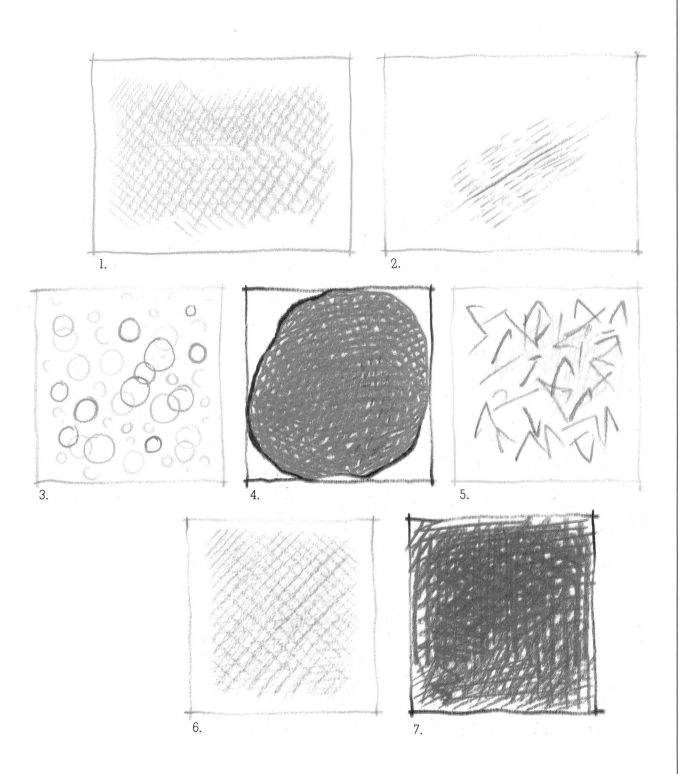

1.

2.

3.

4.

5.

6.

7.

In drawing, as in life, color—depending upon its quantity, quality and placement—can have a major effect on mood. What mood is suggested to you as you isolate each thumbnail drawing from its neighbors? Compare your feelings with these:
  1. Warmth, pleasantness 2. Uneasiness 3. Frivolity 4. Anxiety, maybe absurdity 5. Confusion 6. Serenity 7. Foreboding

# Creating Structure with Color

Try this simple experiment, which contains a key to how color can be used in creating a drawing's structure.

With a black pencil, draw the schematic shown of a circle within a rectangle, and the rectangle divided lengthwise by a line. The elements of this little drawing appear flat, with no feeling of dimensionality. Still using a black pencil, add an illusion of form and space by diagonally hatching the area above the bisecting "horizon" line, and by adding some light horizontal strokes to symbolize a lighter foreground. Add some additional hatching lines as a core shadow to the circle, making it seem a sphere. With these changes in value you have constructed a linear drawing that contains a credible illusion of form and space.

Adding a few appealing colors to this drawing might now seem the logical way to convert to color—and it is often the kind of approach made to color drawing. However, the only truly satisfactory way to accomplish structure in drawing with color is to begin with color. To see how color creates form by itself, outline the rectangle of the schematic with a 922 scarlet red pencil (or combined with a 901 indigo blue). Draw a circle with a 903 true blue and the bisecting line with a 922 scarlet red. These colors—chosen for their particular abilities to advance and recede—will serve as the basis for creating form and structure.

Because the background above the horizon is meant to recede, a 901 indigo blue (a cool hue of low intensity) is a good choice for the diagonal hatching in this area. To bring the foreground forward, begin with a 922 scarlet red near the horizon, warming it with 918 orange as it comes forward, and ending with a 916 canary yellow where it is to read as farthest forward.

Because color also has the ability to suggest form by its shifts in hue under different degrees of illumination, this sphere, which is blue, ought to appear more green where it is most illuminated, and nearer violet where it is least illuminated. To utilize this aspect of color, draw the sphere's core shadow this time with a 903 true blue crosshatched with its adjacent hue of 932 violet. Further restate the bottom of the sphere with a 932 violet, and the top contour—where most light hits it—with the blue's other adjacent, a 910 true green.

You now have a second drawing that contains an illusion of form and space. But note how this second structural illusion, built with a combination of line and color, seems to more clearly state its feeling of form and depth, and also to evoke its own mood.

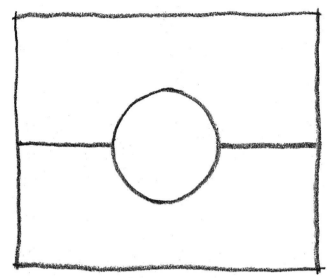

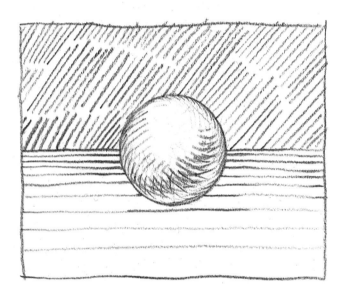

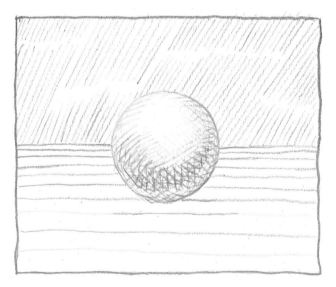

# Tonal Techniques

In the sense that graphite pencils work best with the linear form of expression, colored pencils work best with the tonal form.

Tonal drawing refers to the effect produced by pencil strokes applied so closely together and so compactly that they appear to merge. This is done without smudging or rubbing, and the tones achieved in this way lose almost all suggestion of line.

### HOW TONE IS ACHIEVED WITH COLORED PENCILS

Tones are made with a colored pencil's point (sharp, dull, or blunt) or with its shaft (the side of the lead). The quality of tone produced can be strongly or subtly influenced by the shape of the pencil's point, as well as by the method in which the pencil is used. A slow and careful stroking with a very fine point or the pencil's shaft, will yield a much coarser effect.

Individual temperament also influences color pencil tones. The same pencil in different hands may produce very different tones, with a range in appearance from loosely vigorous to machinelike.

### PENCIL PRESSURE AND PAPER SURFACE

As stated earlier, the pressure with which a colored pencil is applied has a great effect on that color's value. A wide scale of tonal values can be expressed for each color by varying your pencil pressure. The only limitation is that each pencil has its own inherent value, which is what you see when you look at the lead; and it is what determines the maximum dark value available in that pencil.

A paper's surface also plays a critical part in the achievement of colored pencil tones. We have seen how particles of a colored pencil's lead are "filed off" by a medium-grained paper's tooth. This is desirable; it is in fact what makes the unique results of this medium possible. When working with tone, the texture and pattern of a paper or drawing surface become strong factors that must be taken into account. These surfaces are readily apparent underneath medium-to-dark tones, and similarly, a repeating or obviously patterned surface can become an unexpected and unwanted element in a drawing. On the other hand, a particular surface might be exactly what you want. So before launching out full-

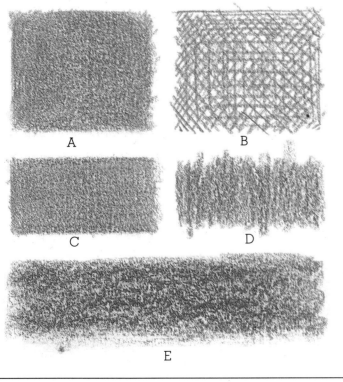

The three tones (above) were made on textured surfaces and show how a pattern is discernible through the colored pencil tone.

The difference between colored pencil tones achieved (left) with a tonal technique and those made with a linear technique can be seen at A and B. The following three variations of tonal technique are made using: C—a sharp pointed pencil, D—a dull pointed pencil, and E—the pencil's shaft.

A

B

C

D

E

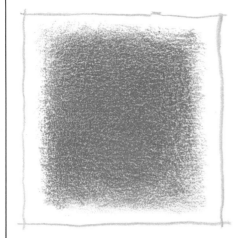

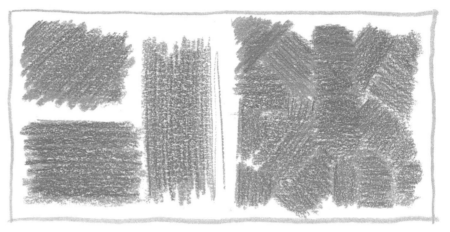

Colored pencil tones can be directional or non-directional. Compare the nondirectional tone at left with those at right, which are diagonal, horizontal, vertical, and "bundled." In directional tones, a slight linear quality is allowed to remain.

scale on a new or untried paper surface, it is always wise to experiment with the paper surface first and find out what effect it will have on your tonal work.

### LAYERED TONES
Because colored pencils are semi-opaque—what we perceive as transparent—the tones made with them are often achieved by layering, the superimposition of one pencil color over another. This technique can result in more subtle and more complex tones.

Layering tones with combinations of pencil colors is an exciting and very efficient method of color mixing. For example, choose a particular pencil color at random and then lay down a row of six good-sized patches of tone. Then choose five additional pencil colors, also at random. Lay down a layer of color over five of the color patches, using a different pencil color for each and leaving one patch of color untouched. You are likely to be surprised at how much your constructed tonal colors differ from the unlayered one and at how many ways in which they differ. There is much to discover by experimenting with random changes.

To make your results more predictable, start again with another six patches of the same tone, this time using one of the primary or secondary hues of the spectrum. Leaving one patch unlayered, add a complementary color to a second patch, and a near-complementary to a third. To a fourth and a fifth patch add the patch color's adjacent hue on each side, and to the last patch add both these adjacents. Now compare the unlayered patch with the first two layered patches—those with complementary and near-complementary colors added—and you will find hues of lessened intensity. The

three remaining patches that are layered with analogous colors will look brighter than the unlayered original, or possibly slightly subdued but no duller. Your experiments here should convince you that color is dependable.

### DIRECTION IN TONES
Sometimes a colored pencil tone shows no trace of line or direction. It appears to blossom of its own volition, with delicate gradations and a look of quiet granularity. It is a tone with an air of elegance. This nondirectional kind of tone is achieved by careful pencil stroking with a fine point, and by changing the direction of these strokes so frequently that you develop no linear quality. For these changes in direction, shift your hand angle often, or shift the paper itself as needed.

However, some colored pencil tones are directional; they reveal an energetic, almost linear thrust. This effect is produced by laying the tones down in a pattern that is consistently diagonal, horizontal, or vertical. This kind of tone can also be characterized by seemingly random changes in direction, or by being organized into "bundles" suggesting a woven texture. A spirited directional tone sometimes gives way to line, resulting in a fusing of linear and tonal techniques..

### HANDLING TONAL EDGES
The handling of edges with colored pencils—whether edges of contours or edges of neighboring colors—can be extremely expressive. In art, the edges we see are compelling elements and are probably fundamental to all our visual perceptions. How we handle our edges in drawing not only delineates shape, it imparts to our work a flavor and mood, and ultimately becomes a telling characteristic of our style.

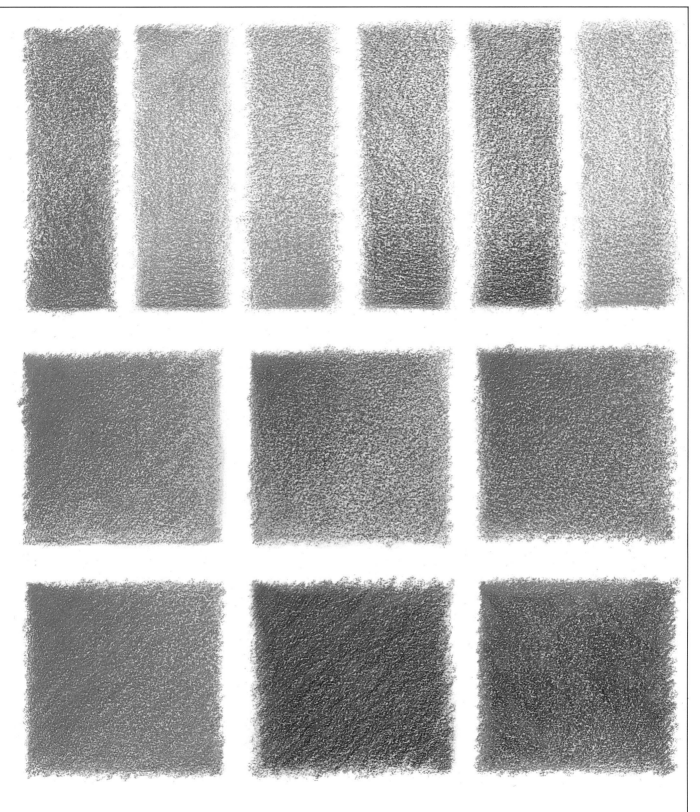

## COMBINING COLORS

How colors combine can quickly be seen when they are tonally layered over one another. In the top row, six patches were made with a 943 burnt ochre. The first patch was left unchanged, and to each of the other five patches a second, randomly chosen hue was applied. These added hues are (reading from left); 916 canary yellow, 929 pink, 911 olive green, 932 violet, and 949 silver.

In the six larger patches, a 924 crimson red was applied first to the patch at left center. This patch remains unaltered. To the first patch at its right was added its complementary hue, a 910 true green; and to the right-hand patch, a near-complementary, 913 green bice. These additions of color appear to reduce the intensity of the original color.

In the bottom row, the original color's two adjacent colors were added—a 918 orange at bottom left, and a 931 purple at bottom center—and to the last patch, both adjacent colors were added. Mixing together adjacent hues will usually subdue an initial color without dulling it.

# Flower with Tonal Technique

It is in the subtle gradations of layered tonal effects that colored pencils excel. The demonstration subject here is a flower, a single peony. The artist wanted the flower to emerge from its foliage background. To do this she employed a finely grained and non-directional tonal technique.

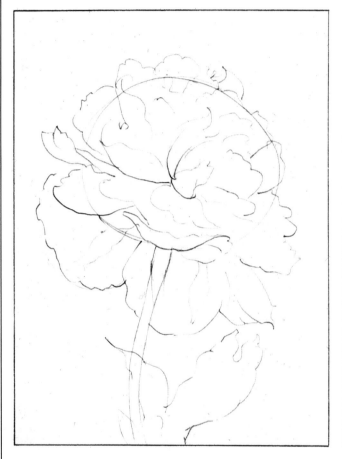

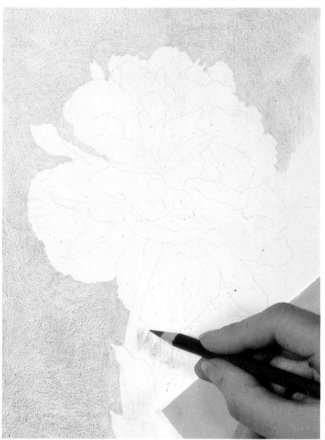

**1.** The artist used a few thumbnail roughs to work out the composition's basic color scheme—a split-complementary of green, red-orange, and red-violet. This initial color scheme was, of course, tentatively dependent on what was needed later. The artist lightly blocked in the peony on a medium-grained drawing paper with an HB graphite pencil. The complex petals were only sketchily suggested at this point, and because its stem seemed too spindly to support the flower's head, a foreground leaf was added to lend visual strength. Background foliage was not laid in with graphite, but was developed as the drawing progressed.

**2.** With a 943 burnt ochre pencil—chosen as a near-complementary of the green that was later layered with it—a tonal layer was applied to the background. The artist kept the pencil sharp to produce a fine grain. For evenness of tone, she maintained a medium pencil pressure and varied her stroke direction frequently.

Applying the burnt ochre to the background firmly delineated the outside edges of the flower, the stem, and its leaf. The graphite contours were progressively erased as these contours were restated with color. This firming up of outside edges suggests additional inside contours for the flower, and these were lightly laid in with more graphite. A small sheet of newsprint under the artist's hand protected the drawing surface.

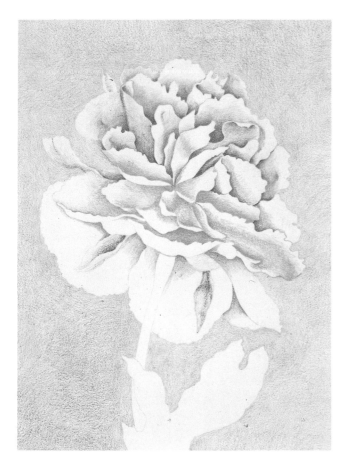

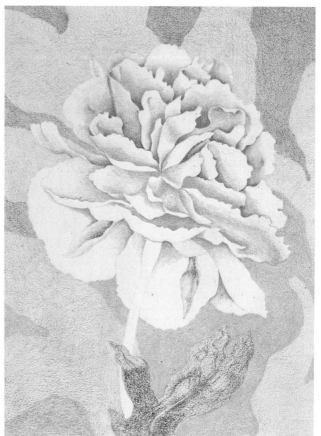

**3.** At this stage the artist added a first underlying layer of tonal color to various parts of the flower. The pencils she used are: 933 blue violet, for that part of the flower that is farthest back; 931 purple, for the core of the flower; and a 922 scarlet red, for the area most forward. A 911 olive green was used to model the bud jackets.

Besides setting up spatial structure, these three underlying colors on the flower also delineate the contour edges of the individual petals. This multi-petaled flower is easier to draw than you might think. It is basically a matter of arranging a color's values to contrast light against dark. The darkest values, and consequently the tones made with heaviest pencil pressure, occur where each petal begins. The color then lightens in value as it spreads toward the petals' edge.

**4.** The top peony leaves in the background were delineated by creating a negative space around them with a layer of 967 cold gray, light. The bottom leaves, those farthest forward, were delineated in the same way with a layer of 968 cold gray, very light. The foreground leaf was also toned with a 911 olive green pencil to indicate a suggestion of modeling, and a few slight linear elements were added to denote leaf veining.

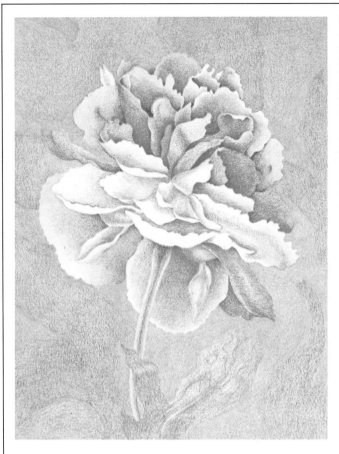

**Evaluation:** The artist paused to objectively evaluate her drawing's progress. She felt her main problem was the color of the peony—it looked as if it were made up of three different hues. Her solution was to work more 922 scarlet red into all the petal areas, so the red-orange color would dominate. Fortunately, the drawing seemed to have no "worry spot." But the linear veining in the foreground leaf was not working well—probably because it was too isolated, with no similar line work anywhere else. Lines of this kind are not erased with colored pencil, but are made invisible by toning around them with a matching value.

Some of the leaf tones also seemed too ambiguous in some places. The artist felt a slight crispening and darkening of edges could add the needed clarity without overstating them.

**6.** To complete the drawing more 922 scarlet red was integrated with all of the flower's petals. Some 933 blue violet was added in the area behind the left bud jacket for better modeling; and some 916 canary yellow was lightly applied to the flower's petals nearest the front to help project them forward. Tones were generally refined and evened out and, of particular importance, a firmer gradation of hues and values was made on the flower's two lower back petals.

The artist used a 931 purple pencil on the left bud jacket, but not on the jacket at the right. The core shadow of the flower's stem was also darkened somewhat with the same pencil, and leaf edges were darkened slightly where they merged too much with the gray. In the vein area of the foreground leaf, the artist used a 911 olive green pencil to effectively "blend away" most of the line work. Enough modeling was allowed to remain, however, to suggest this leaf's supportive function for the flower.

**5.** With the drawing's structure thus established, its additional layers of color were tonally added. A 909 grass green was carefully layered onto the leaves at the top. Again, the pencil was kept sharp and the artist moved it in various directions. She avoided abrupt changes in value, because she wanted the leaves to be somewhat indistinct and just faintly seen. A 911 olive green was applied similarly to the leaves at the middle and bottom of the drawing. This layering of greens with the original 943 burnt ochre constructed a natural looking green of low intensity.

A 931 purple was applied over the flower's blue petals to reinforce the value changes already established by the original blue. A small amount of 916 canary yellow was added to the center petal, and 922 scarlet red was applied over these petals previously toned with purple. Although colored pencils do not blend by rubbing, extremely delicate gradations of tone can be achieved by careful modulation of pencil pressure and by maintaining a sharp pencil point.

For the stem of the flower, a 911 olive green and a 931 purple were layered to suggest a core shadow.

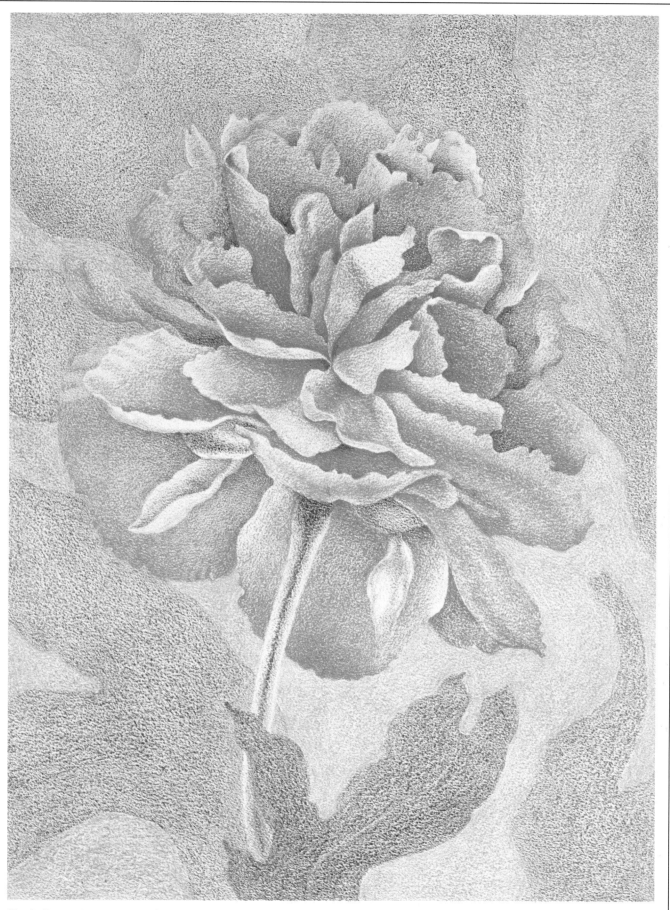

*Single Peony 2*, 6⅝″ × 8¾″ (16.8 × 22 cm),
by Bet Borgeson

# Flowers on Paper with Gesso Surface

Sometimes a tonal drawing can benefit from a textured surface. Polymer gesso is an excellent surface, with a texture more varied than that provided by a machine-patterned paper. This is a ready-made product, resembling thick cream, and sold in art supply stores under many brand names. It is fast drying, and a single coat of it brushed on a sheet of drawing paper yields a textured, flexible, brilliant white surface.

Drawing tonally on this surface emphasizes a brushed texture, which becomes an element in the drawing. It is a surface that also encourages a certain broadness and looseness of line.

**1.** After working out a simple arrangement with thumbnail roughs, the artist lightly blocked in the hydrangeas and some of the foliage with an HB pencil. This was a fairly spontaneous drawing, developed as the artist went along, so not much drawing with graphite was done at this stage. What is shown here, in fact, is darker than it need be. These lines should be very light, because this time they will not be erased.

**2.** This is where the drawing really started. With an 833 blue violet pencil and medium pencil pressure, areas of negative space were tonally drawn to reveal the foliage forms. Drawing this negative space is sometimes the easiest way to see and state these kinds of complex and crowded forms. If you know where your foliage begins (at the ground), and where it ends (in and around the flowers), you can make a beginning by free drawing dark spaces between your not-yet-visible fronds. And because at this point the dark spaces were not very dark, they could have been made darker—or turned into a frond. In this kind of drawing, the composition is at this stage still fairly transitional.

The artist began modeling the hydrangeas with a 929 pink and a 956 light violet, used separately and together. Much of the gesso surface's brilliant white was left open for the mounding flower heads. Here the brush marks in the gesso were becoming slightly apparent.

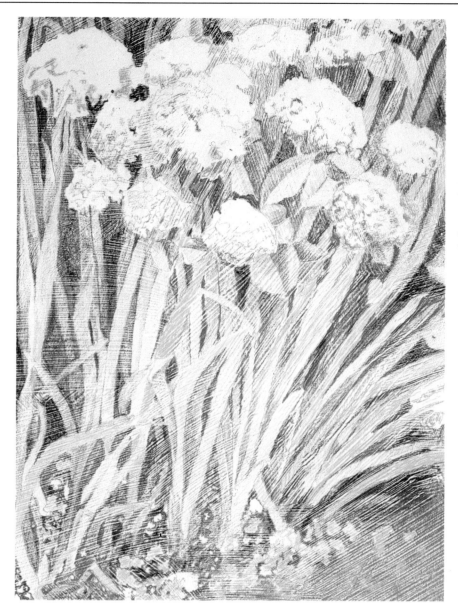

**3.** The fronds and leaves were now tonally drawn with four greens: a 910 true green, a 911 olive green, a 912 apple green, and a 913 green bice. These different greens helped to refine and differentiate the foliage and to add a suggestion of depth. Spaces between the leaves were darkened with 931 purple and more 933 blue violet. The artist also applied some 911 olive green with heavy pressure to suggest additional foliage in these spaces. In the lower right foreground, some 903 true blue and a few touches of 910 true green were also added. Although the hydrangea blooms have not been altered, they project more now that the foliage is better developed.

**Evaluation:** This drawing moved along loosely and fast for the artist. So, before adding a lot of details, she paused to evaluate her progress, and to determine what else needed to be done.

Two things became quickly apparent: the foliage lacked definition near the lower foreground and in the lower right-hand clump; and, more seriously, the flowers themselves didn't quite seem to register. Although their characteristic look was supposed to be rendered loosely, something was lacking. Reviewing the three dimensions of color, one by one, seemed to offer a clue. While the general value range of the flower looked about right—light at their tops and darkening at their rounded sides—their hues were too much the same. This was probably what made them a bit boring. The intensity of their colors also lacked contrast. So, what the flowers needed was more variety of hue and more contrast in intensity.

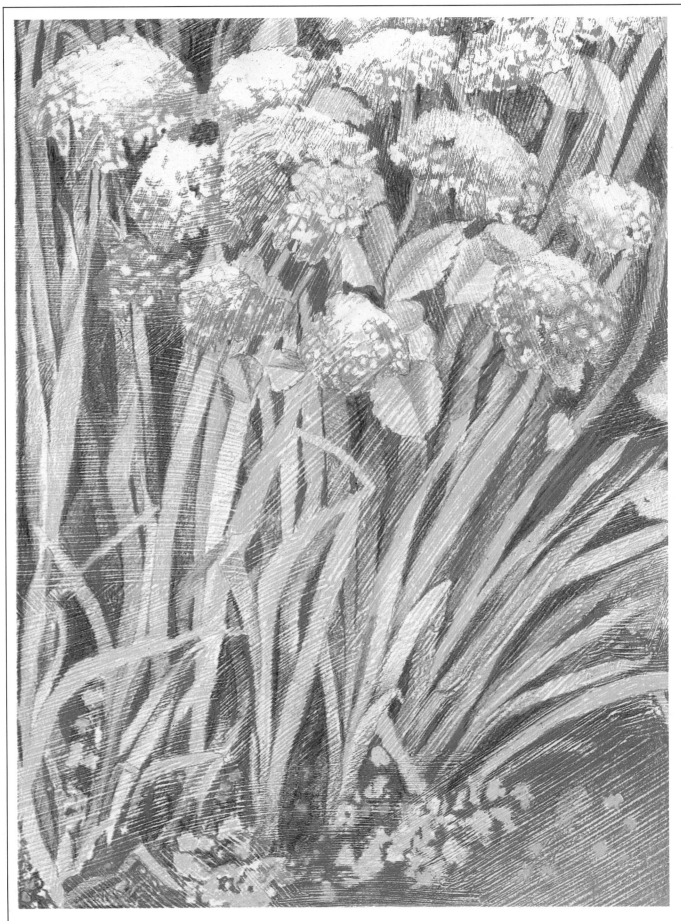

*Garden Hydrangeas*, 6⅝″ × 8¾″ (16.8 × 22 cm), by Bet Borgeson

**4.** A few bright hues were briskly added to the hydrangeas. For the flowers in front, a 923 scarlet lake, a 916 canary yellow, and a 918 orange were used. For the flowers in back, the hues added were a 903 true blue and a 956 light violet. This addition livened them up.

To further define the foliage where necessary, the artist played down the linear quality of the gesso texture. To do this, more greens, and some blue and purple were added, applied with sharp pencil points into those grooves of the texture where saturated darks or crisp edges were needed.

The close-up view above shows how pencil tones in this drawing were deposited on the gesso ridges. A sharp pencil point fills in grooves for more color saturation at top center. Note, too, that in this view, the flower petals were loosely suggested rather than drawn individually.

# Burnishing

A white colored pencil cannot be used to render white unless it is used on a toned or colored paper; but it does have another important use unique to the colored pencil medium. This is its use in adding a glazed surface effect to a drawing or to parts of a drawing. This technique is called "burnishing," and its effect is unlike that produced by any other method.

## HOW BURNISHING IS DONE

The burnishing technique is done by applying a white—or a similarly light-valued pencil—with heavy pencil pressure over a previously established tonal area. The Prismacolor pencils most suitable for burnishing are 938 white, 914 cream, 964 warm gray, very light, and 968 cold gray, very light. The character of the original tonal colors changes as pigment material and paper become tightly compressed. Although the original colors become slightly lightened, because of the addition of light-valued pigment, the overall effect is an increase in color brightness and reflectivity as the original tonal hues are mashed into the paper's surface. This technique can also appear to evoke a wet or fluid effect.

In practice, burnishing can be employed at any stage of a drawing. It can be integrated into the initial process of drawing, or it can be used as a final step. Burnishing works well over any colored pencil hue or value. It is most effective, however, when employed over tonal areas rather than those of a loose or linear nature. Also, the less hue contained in the burnishing pencil, the less the original color will be altered. A 938 white pencil, for example, will burnish a color with less change to that color's hue than will a pencil with a similar value, such as a 914 cream, which contains more hue.

## DRAWING OVER BURNISHED AREAS

As an aesthetic option, additional color can be applied over a burnished area. In regard to color mixing, a pencil color that is layered over an area of firmly applied white results in a more intense version of that pencil's color.

To see for yourself how burnishing glazes a drawing's surface and appears to heighten color, try it on some sample patches in your own workbook. Start with a few suitable pencils. Apply each of these with heavy pressure over some random samples of single and complex tonal hues.

To see how much or how little the underlying color is affected by the color of the burnishing pencil, experiment with different pencil colors layered over tonal patches of the same hue.

Burnishing is an interesting and useful technique. However, like other techniques that use heavy pencil pressure, it can lead to wax bloom. As a precaution, it is wise to spray burnished areas with a good fixative.

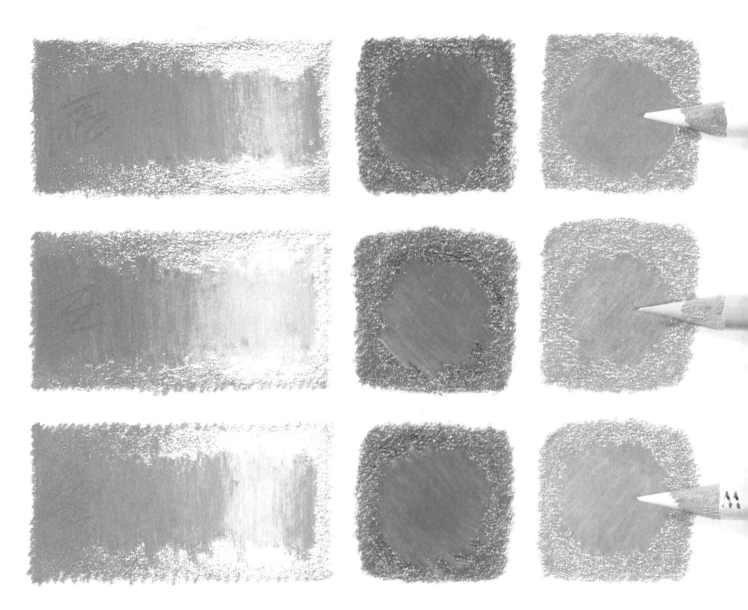

The difference between these two studies (left) based on a textile design is that the version on the left remains as drawn while that on the right has been burnished as a final step with a 938 white pencil. Among the effects of burnishing are an apparent heightening of intensity in some of the colors, a smoothing of overall texture, and a general lightening of values.

The illustration (above) shows the slightly different burnishing effects of three light-valued colored pencils on three patches of color. The patches are (from left to right): a single layer of 931 purple; a layer of 931 purple over a layer of 933 blue violet; and a layer of 918 orange over a layer of 931 purple. The pencils used for burnishing were (from top) a 938 white, a 968 cold gray, very light, and a 914 cream. As can be seen, dark tonal values are least affected by the burnishing pencil's color, while lighter values and single layers are most affected by it.

# Effects of Burnishing

Colored pencil burnishing is a versatile technique. It is also one that must be actually done for a full appreciation of its possibilities for fine manipulation of a drawing's surface. Like most techniques that rely on heavy pencil pressures, burnishing also can give a drawing a painterly quality.

Although the elements in this next drawing include a variety of object surfaces—including glazed ceramic ware and a rubbery jade plant—all these surfaces can be burnished—and all with different results.

**1.** On a resilient paper, the elements of this drawing's composition were laid in with a graphite pencil. The dominant color scheme is a primary triad of red, yellow, and blue, with secondary mixtures of orange, violet, and green.

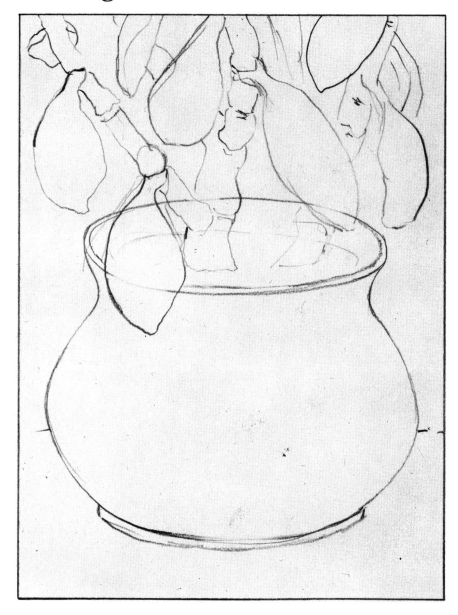

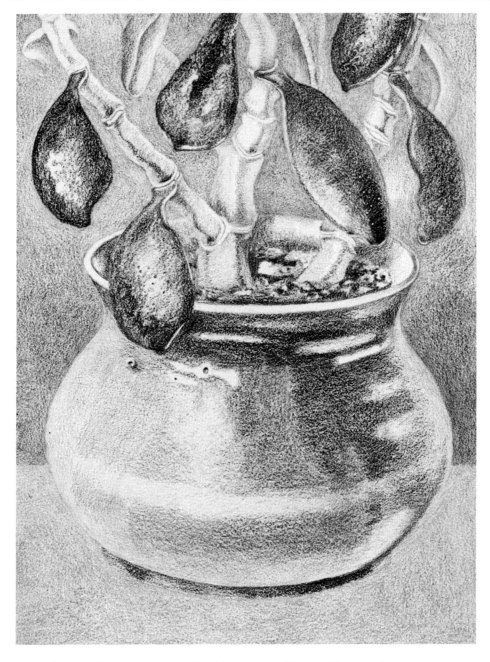

**2.** The first tonal hues were applied at this stage. Because values darken as additional layers are added, these first layers of color were kept rather light. A 918 orange was used for the tabletop, a 931 purple for the background. For the branching stems of the jade plant, the artist used a 948 sepia as a basic color, combined in some areas with 911 olive green and 932 violet.

The leaves—developed earlier than some of the other elements because they are not to contain many color layers— were drawn with a 911 olive green and some 903 true blue as reflected light. A few surface pores previously impressed with tracing paper are revealed here.

The dominant hue of the ceramic container is 933 blue violet, with an area at its center toned with 924 crimson red and 922 scarlet red to suggest local color changes. The artist used a 942 yellow ochre pencil at its bottom to indicate a reflection of the tabletop. Note how in several places the white of the paper was preserved for highlights. The soil in the container was suggested with light and dark patches of 937 Tuscan red.

**3.** Additional layers of color were carefully and evenly applied over the first layers. In the background, 918 orange was added to the lower right side of the background. The artist also used a 929 pink near this area, at the rear of the tabletop, and a 916 canary yellow toward the front. Some 901 indigo blue was added to the soil in the container. The artist added some 931 purple and a little 903 true blue to the container itself.

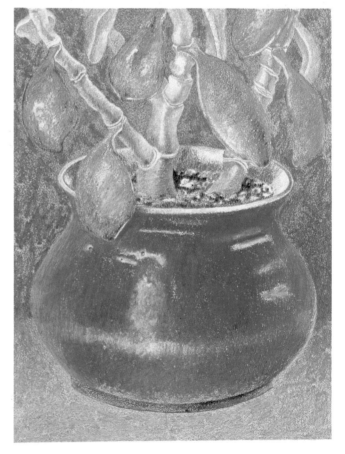

**4.** For the burnishing, the artist started with the container, and used a 938 white with heavy pressure as the burnishing pencil. She disregarded shapes and boundaries of color as she layered the white evenly over them. On the leaves and the plant the white was layered loosely over the dark and medium values, but it was not used on the very lightest values. For the background and the tabletop, the artist applied the 938 white more loosely still, almost linearly. Some of these areas were left unburnished.

**Evaluation:** Among the effects of burnishing is a general overall lightening of values. When burnishing is planned as a last and final step for a drawing, you can take this into account beforehand, and you can deepen your values in preparation. When burnishing is part of your drawing process however, some values will need restating.

In this drawing, some of the dark values needed firming up, especially those in the container and in the leaves. The leaves at the rear needed to be subdued. There was also too much contrast in the plant's branching stem, which needed to be reduced. The yellow foreground appeared to need a bit of lightening, and the soil in the container seemed to need more development: more hue and more complexity of value.

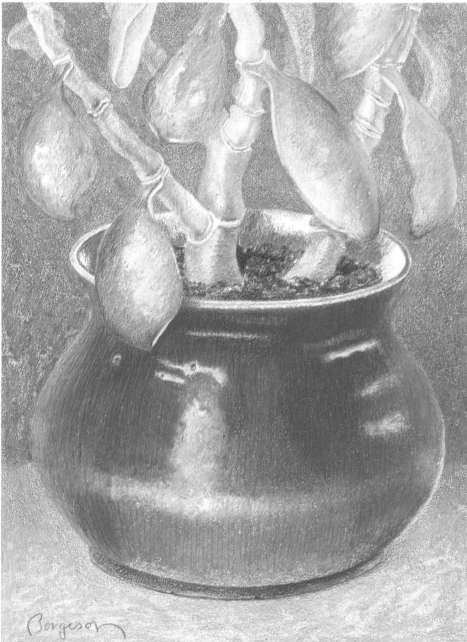

**5.** The drawing was completed by adjusting the various value contrasts. To restate the dark values in the container, some 933 blue violet and 924 crimson red were drawn linearly into the burnished tonal areas, following the container's general contours. A similar darkening was given the plant's leaves and stems with 911 olive green and 903 true blue. Some 948 sepia was also added to the leaves, and some 968 cold gray, very lightly to the stems. A 937 Tuscan red pencil was lightly applied to the three leaves at the rear to lessen their contrast with the background.

The soil in the container was further developed and darkened with four hues—911 olive green, 924 crimson red, 918 orange, and 932 violet. To lighten the burnished yellow foreground, the artist firmly pressed a kneaded eraser onto it. This lifted away the pencil material not covered by burnishing, but did not change the burnished areas, which produced an effect of sharp value contrasts.

*Potted Jade*, 6⅝″ × 8¾″ (16.8 × 22 cm), by Bet Borgeson

How vertical colored pencil lines are drawn back into a burnished area can be seen in this enlarged detail. Although the primary purpose of these lines is to darken value, they also reveal a gain in intensity because the burnished surface is slightly more reflective than an unburnished surface.

# Using Colored Pencils with a Solvent

## USING TURPENTINE OR WATER

All colored pencils are to some degree turpentine soluble, but only some brands are water soluble. Those that are water soluble include the Caran D'Ache Supracolor, Venus Watercoloring, and Mongol brands. The Prismacolor and Spectracolor brands are among those that are not water soluble.

For the look that most closely resembles watercolor or painting, the water soluble pencils work best. Pencils that are only turpentine soluble also yield a fluid and painterly effect, but they do so with less conviction. Unlike the water-mixed leads, which flow smoothly, the turpentine-mixed pencils produce washes of a speckled and slightly clumped look. On the other hand, because the turpentine-mixed pigment dries in less time on the paper than the water-mixed, you can work at a faster pace with a turpentine solvent.

However, the point here is not to discover which of these two solvents is better—because neither is—but only to understand the nature of their differences in solubility and how this influences how you handle a particular type or brand of colored pencil. In either case, there are two basic approaches to using solvents with colored pencil:

1. *The solvent is added only where needed for spot blending and intensification.* This is done by simply dipping a colored pencil's point into a cup of solvent or into a solvent-saturated cotton ball; a rolled paper stomp (tortillon) or a watercolor brush dipped in solvent can also be used to apply the solvent to the surface. This kind of spot blending is particularly suitable to the more easily controlled turpentine-soluble pencils. They also dry almost instantaneously.

2. *The use of a solvent is integrated into the drawing process from its earliest stages.* In this method, lines or tones are used to establish elements, and brushwork with a solvent used to move around and modify areas of color. Further additions of pencil are then worked into the surface. This is a dynamic way of combining colored pencils with solvents, and one in which distinctions between drawing and painting begin almost to vanish. While water soluble pencils often excel at this kind of technique because of their easy fluidity, it is by no means limited to them.

An important thing to remember when experimenting with the integrated method of using solvent is, the more colored pencil material that is placed on the paper, the more color you will have for the solvent to liquify and spread. Likewise, the less pencil on the paper, the less the pigment will spread. This is an important key to gaining control. Also, this method's similarity to working with watercolor requires a paper that is suitable for use with liquid media—thus, a paper not prone to buckling.

## USING COLORLESS MARKERS

Some manufacturers of felt-tipped art markers also offer unpigmented or colorless markers. They contain only a solvent for liquifying or blending the colored markers. These colorless markers (or blenders) can also dissolve the binder of most colored pencils. In addition, their sturdy felt tips provide the additional friction often needed to freely move the dissolved pencil pigment around the paper.

Colorless markers offer a relatively new and unique way of working with colored pencils and solvent. With an unpigmented marker, a fine-art quality pencil such as Prismacolor or Spectracolor can be used with almost the speed and sureness of a felt-tip marker, yet still retain the colored pencil's vitality of color and permanence.

The methods with which unpigmented markers are used with colored pencils are similar to those methods used with water or turpentine. The marker's felt tip can be a swift color intensifier, a means for rapidly lightening or softening an image, or a tool for gaining a more active or gestural surface effect. When using the marker, a sheet of scratch paper is kept nearby to "run out" the picked up color from the felt tip. One of the advantages of using a colorless marker is that almost any drawing paper can be used with no danger of buckling.

## USING COLORED MARKERS

Although using colored markers as a solvent is not a process that gains its effect by dissolving the colored pencil's pigmented material, as are colorless markers, they are frequently used for similar effects. So for this reason, they can also be regarded as a way of combining colored pencils with a liquid medium.

When using colored felt-tip markers with colored pencils, broad areas of color are usually first established with the markers; then pencil colors are laid over the marker color for details of form or texture. The mixing of the semi-transparent pencils with the underlying

A solvent brushed into pencil pigment can liquify colors individually or in layered combinations.

marker colors adds a quality of luminosity to the pencil colors similar to that gained with a colored or toned paper.

Because color can be quickly and accurately established with the markers and texture and detail easily added with colored pencils, commercial artists and designers often use this combination. The only disadvantage is that markers lack color permanence. However, when long-range permanence is not an issue—as is often the case with color design and graphic work—the combining of colored markers with colored pencils offers a swift and versatile way of getting the best from two sources of color.

When you start to experiment with this technique, you will find that there are many suitable brands of colored markers on the market. If you are already using Eberhard Faber's #311 colorless blender, you may want to add a few colored markers from this manufacturer's "Design" series. But whatever colored markers you choose, a general palette of primary, secondary, and tertiary hues—all of less than full intensity—is recommended, plus a few earth colors and neutrals.

A helpful guide when combining colored pencils with colored markers is to choose those colors that contrast well with each other. For example, a light-valued pencil shows well over a dark-valued marker, as does a pencil of bright intensity over a duller marker. Again, personal experimentation is the surest and fastest way to discover how colors and texture mix best for your own purposes.

**MIXED WITH TURPENTINE**

**MIXED WITH WATER**

**Different characteristics of fluidity can be seen in these examples of turpentine and water soluble pencils. The pencil pigments of Spectracolor and Prismacolor (left) are turpentine soluble and disperse less evenly than the Caran D'Ache Supracolor and Venus Watercoloring pencils, which are water soluble.**

**The speckled effect resulting from use of turpentine as a solvent can be better seen in the close-up view below of the two center pencils.**

# Achieving a Painterly Effect

To see how using colored pencils with a solvent differs from using them dry, compare these two similar quick sketches. Bet Borgeson planned to draw the lily on the left, using colored pencils as a dry medium. She planned to paint its twin-in-reverse on the right, using colored pencils as a wet medium.

**1.** The beginning for both sketches was the same, despite the artist's plan to draw one and paint the other. She used a sheet of two-ply white Strathmore bristol for her paper surface. Colored and toned papers do not work well with colored pencils as a wet medium, since the solvent creates a dark trail that is confusing to work with.

Because the painted lily was going to contain more than solvent accents, the artist used water soluble pencils for it rather than turpentine soluble pencils. She selected the Swiss-made Caran D'Ache pencils—a good water-soluble brand. A Caran D'Ache red-orange #070 was used to very lightly block in both flowers on dry paper. A yellow-green #230 was used to define the stems.

**2.** The artist drew the lily on the left with four Prismacolor pencils and no solvent. The colors—931 purple, 923 scarlet lake, 918 orange, and 916 canary yellow—were applied in tonal layers for the flower, with some 913 green bice added for the stem.

She handled the lily on the right a little differently. Colored pencil was tonally applied where she wanted. But this was done rapidly and loosely. Much less pigment is needed when water is to be brushed into it. In the long horizontal body of the lily, for example, two Caran D'Ache pencil colors—a red-orange #070 and a yellow-orange #030—were applied for the darkest area under the curl of the petal. Then the artist used a #10 red sable round brush, dipped in water and lightly blotted on a cloth, to drag the color from right to left. After this was done, there was still enough wet color in the brush to break the linear boundary and push some color beyond the lily's contour edge.

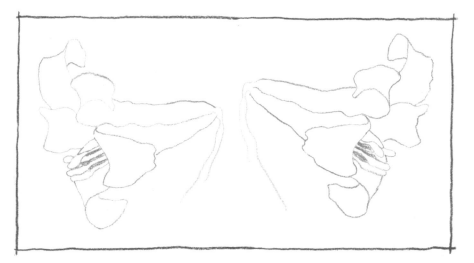

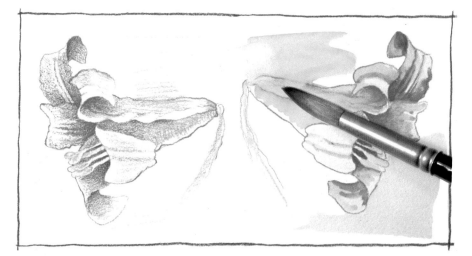

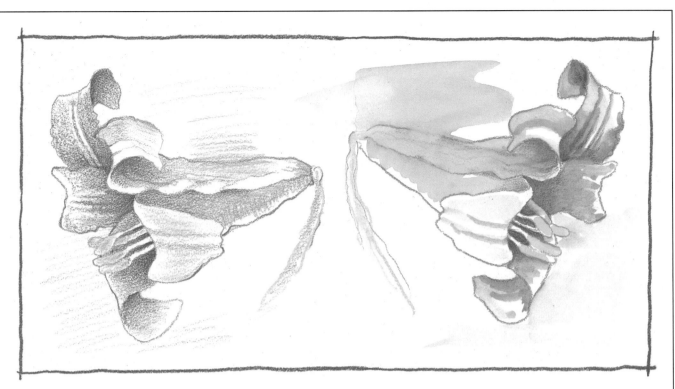

*Two Lilies*, 6¾″ × 3⅝″ (16.8 × 9 cm), by Bet Borgeson

**3.** A few minutes later, the paper was dry enough to draw back into some of the painted areas. (Had Prismacolor and turpentine been used, the wet surface could have been used or drawn back into immediately, without the few extra minutes of waiting—but the tones might have been a bit less smooth.) One advantage of this method over conventional watercolor becomes apparent at this stage: refinements of darkening a value or crisping an edge can be done with the tip of a pencil that is exactly the hue of a surrounding color.

Comparing these two sketches shows some of the differences between colored pencils used dry and wet. But did you notice that the lily in the dry version needed a fourth pencil—a 916 canary yellow—to achieve an intensity similar to that accomplished with three pencils in the wet version? And not only does the use of a solvent usually increase color intensity, it increases speed. The wet version here took only half as long to do as the dry.

A close-up of the lily on the left shows the characteristic granular look of colored pencils applied tonally, with no solvent used.

The same area of the other lily shows how colored pencil can be applied dry over a previously washed area to refine or modify a detail or value.

# Using a Colorless Blender

Using colored pencils with an unpigmented art marker is unlike any other technique used with this medium. It offers an opportunity to manipulate a painting surface in a particularly gestural and energetic way. There are usually three basic steps in the process.

**1.** For this quick study of a few tangelos on a patterned field, artist Bet Borgeson used Prismacolor pencils to rough in the elements on a sheet of regular drawing paper. (Art-quality pencils blend smoothly with colorless markers, and paper buckling is not a problem.) In addition to establishing the relative positioning of the tangelos, the pencil pigments served as colors for the unpigmented art marker.

Layering of different colors at this stage is apparent, but it was done loosely and gesturally. She used 949 silver with some cooler 903 true blue toward the rear for the checkered pattern. The tangelos were established with two basic colors—923 scarlet lake and 918 orange—but she also used 916 canary and 922 scarlet red for the tangelo in the foreground. For additional dark values, a 903 true blue was used on the single fruit at the rear, a 911 olive green on the middle row (as well as for the stems and leaves), and a 949 silver on the front tangelo.

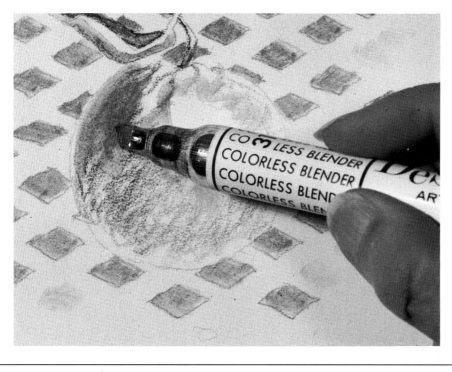

**2.** With an Eberhard Faber #311 colorless blender, and using a gestural stroke, the artist blended the previously applied colors. She left plenty of white paper because once it is covered it cannot be recreated. As the colorless marker was moved from one colored element to another, its felt tip was "run-out" on a sheet of scratch paper to restore the felt tip to unpigmented solvent. Sometimes, however, a picked up color in the felt tip can first be applied someplace where a light valued wash is needed. The artist added some additional checkered squares in this way.

*Arrangement of Five Tangelos*, 6⅝″ × 6⅝″ (16.8 × 16.8 cm.), by Bet Borgeson

**3.** It was in this third step of using colored pencils and colorless blender that the character of this technique's work was defined—whether it was to be a study or a finished expression. This depends in large part on how far a drawing's refinement can be carried with dry pencils.

Without having to wait for the surface to dry, more pencil color was now worked into the painted areas. The original pencils were used again, this time to soften and integrate values that model forms of the fruit. Also, some outside contour edges were crisped and texture added. A 916 canary yellow was added to the small center tangelo and to

the forward one. Some 931 purple and 956 light violet were also added to the forward one, and some 948 sepia was toned into its stem and leaf as added dark value. Although there was now less white paper showing through, it still played an important part in achieving sparkle on the fruit surfaces.

Finally, the artist developed cast shadows by both dry and wet toning beneath and around the fruit with a combination of 949 silver and 903 true blue. A stripe was suggested in the pattern by drawing it in with a 956 light violet pencil, softening it with the blender.

**Detail.** A close-up view of the front tangelo's shaded side clearly shows some of the results of this technique's basic steps. The yellowish hue is 918 orange combined with 916 canary yellow that has been liquified and manipulated with the colorless blender. The colors of the 922 scarlet red, 931 purple, and 956 light violet pencils are those applied dry over the painted area. The firm contour line of 922 scarlet red was added last and not modified with solvent. Bits of white among the colors remain as the sparkle of bare paper.

# Index